B

D0764321

For John -
The Family Man -
Train Man -
with love on
your birthday 2002
Kay & Larry

ANDREW CROSS
SOME TRAINS IN AMERICA

PRESTEL. MUNICH. LONDON. NEW YORK

0006: SOUTHERN CALIFORNIA 0030: TEXAS 0040: APPALACHIA 0062: NORTHEAST

0088: MIDWEST 0114: NORTHWEST 0140: CENTRAL CALIFORNIA

THE AVERAGE LENGTH OF A NORTH AMERICAN FREIGHT TRAIN IS 5,453 FEET. ITS WEIGHT CAN REACH OVER 18,000 TONS. DEPENDING UPON TERRAIN, SUCH A TRAIN REQUIRES AN ENGINE CAPACITY OF 25,000 HORSEPOWER OR MORE. TODAY MAJOR U.S. RAILROADS OPERATE OVER 20,000 LOCOMOTIVES. >>> AFTER NEARLY TWO CENTURIES THE AMERICAN RAILROAD REMAINS CENTRAL TO THE U.S. ECONOMY: AT THE TURN OF THE NEW CENTURY AND AFTER A PERIOD OF RENEWED GROWTH, OVER 1.3 TRILLION TON–MILES OF FREIGHT ARE MOVED ANNUALLY BY RAIL, MORE THAN EVER BEFORE. >>> THE PHOTOGRAPHS IN THIS BOOK WERE TAKEN DURING TEN JOURNEYS MADE IN THE U.S.A BETWEEN 1994 AND 2001. THEY ARE THE RESULT OF THOUSANDS OF MILES OF TRAVELING, FOLLOWING RAIL LINES AND VISITING TRAIN YARDS. >>> WHETHER SEEN FROM CLOSE TO OR FROM AFAR, AMERICAN FREIGHT TRAINS DO MORE THAN DOMINATE THE SPACE AROUND THEM. THEY ARE A KEY PART OF THE FABRIC OF A NATION, LINKING ITS INDUSTRIES AND COMMUNITIES. THE FAMILIAR PRESENCE OF THE RAILROAD HELPS DEFINE THE AMERICAN LANDSCAPE.

ANDREW CROSS >2002

SOME TRAINS IN AMERICA: SOUTHERN CALIFORNIA >DOLORES CA 1997

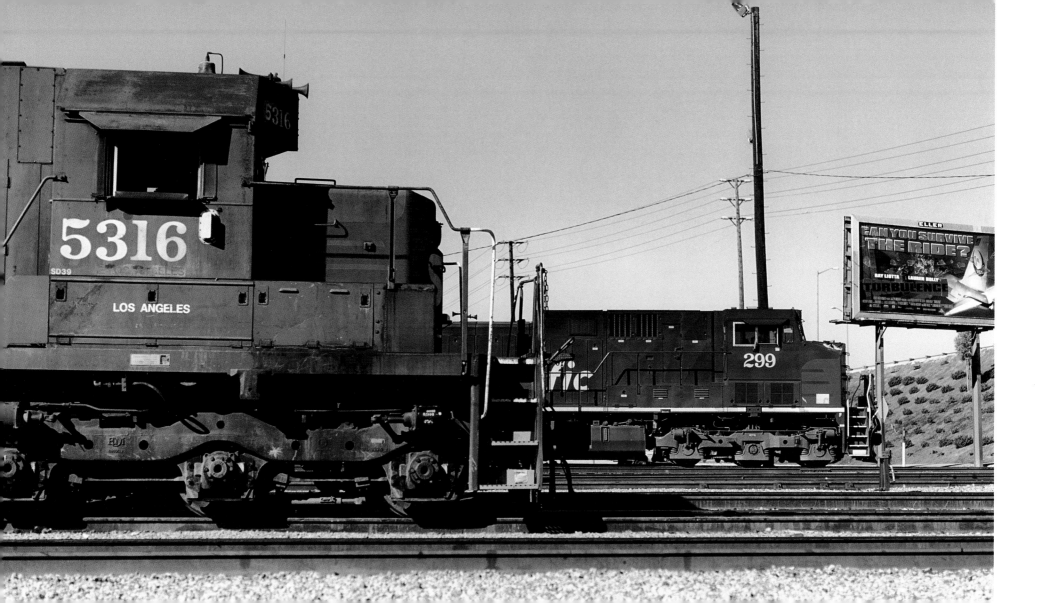

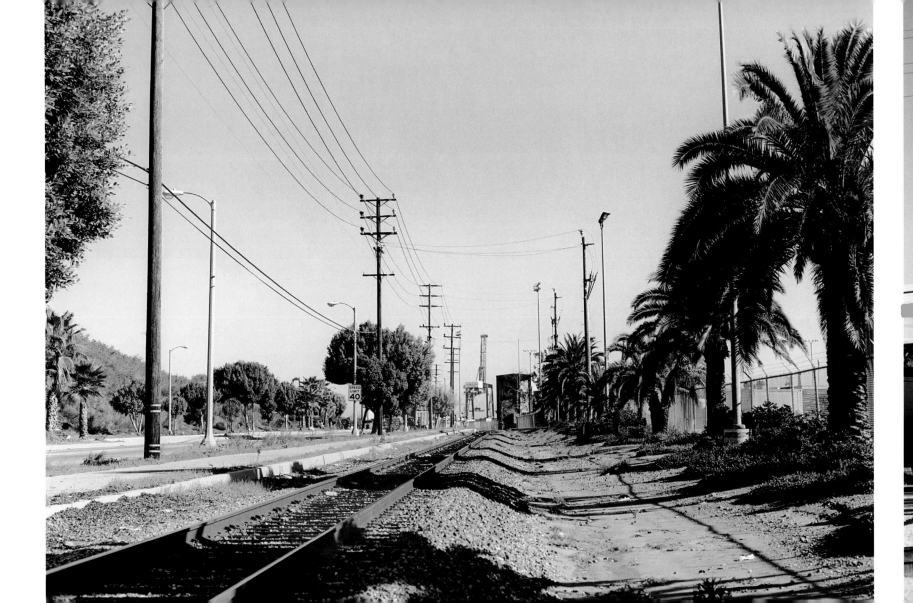

0008

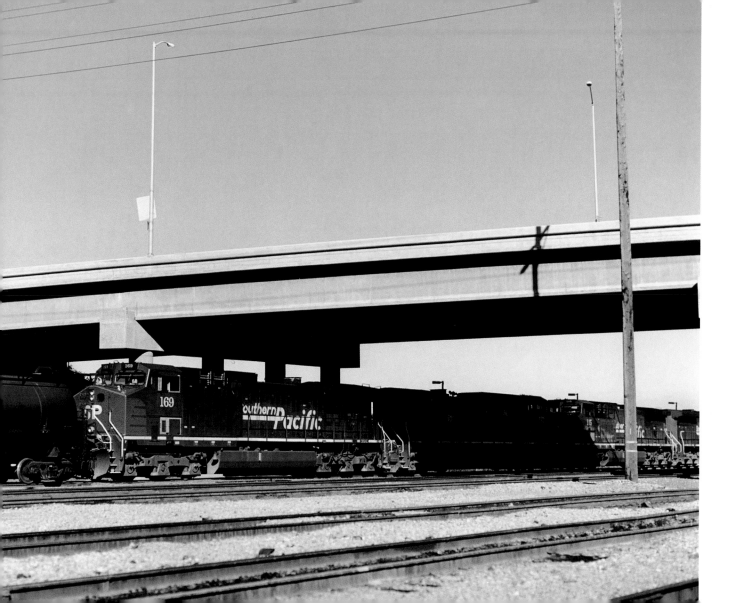

<<EAST SAN PEDRO CA 1997
<DOLORES CA 1997

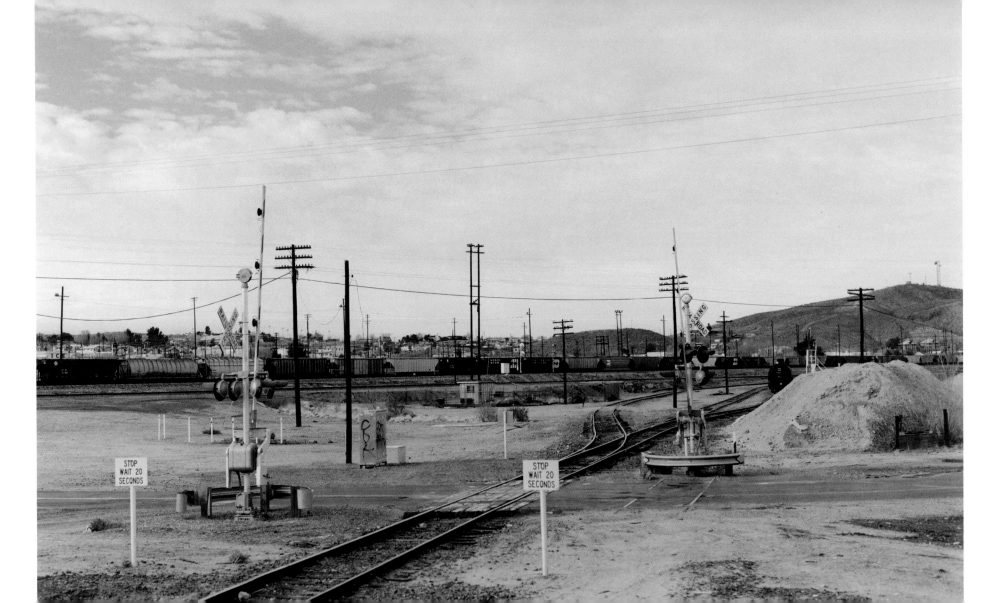

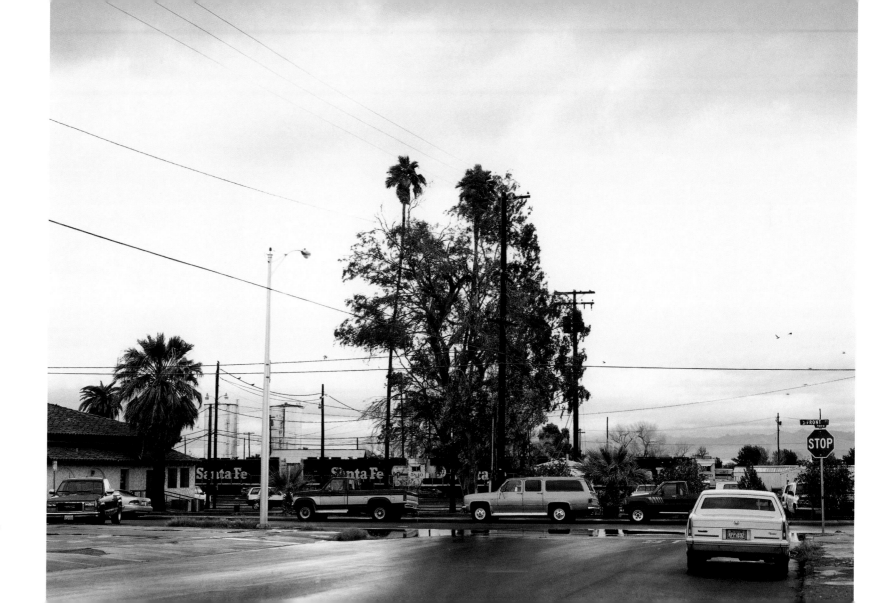

‹BARSTOW CA 1997
›NEEDLES CA 1997

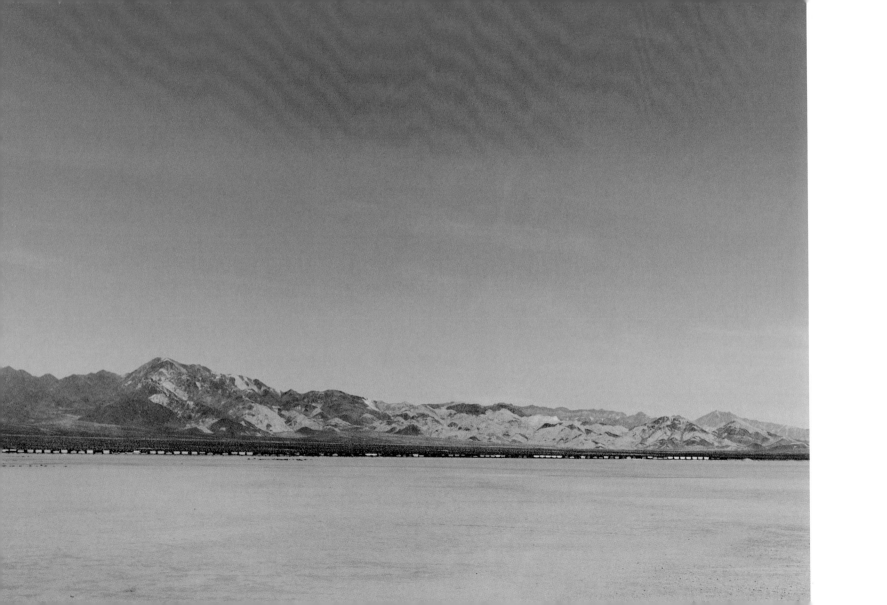

<.>AMBOY CA 2000

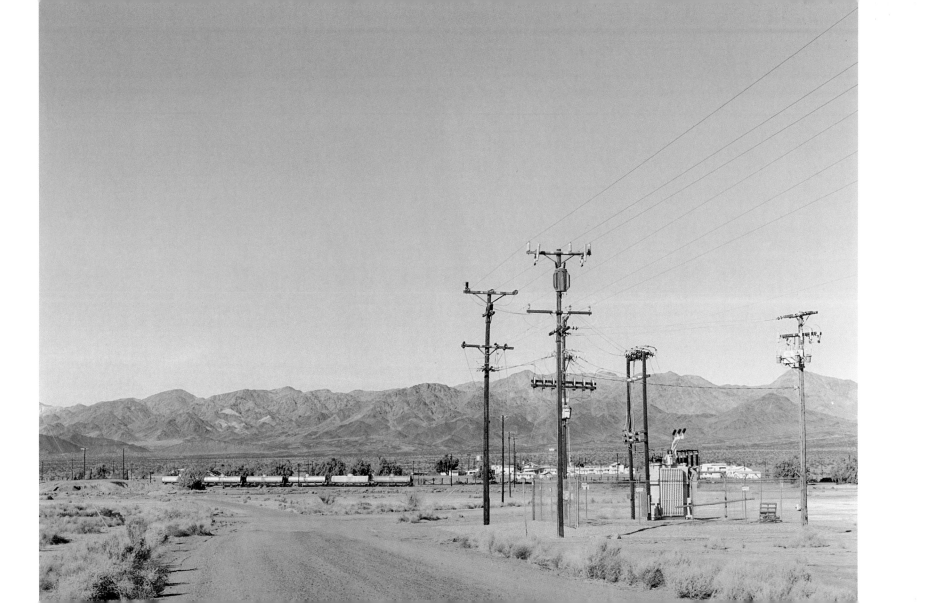

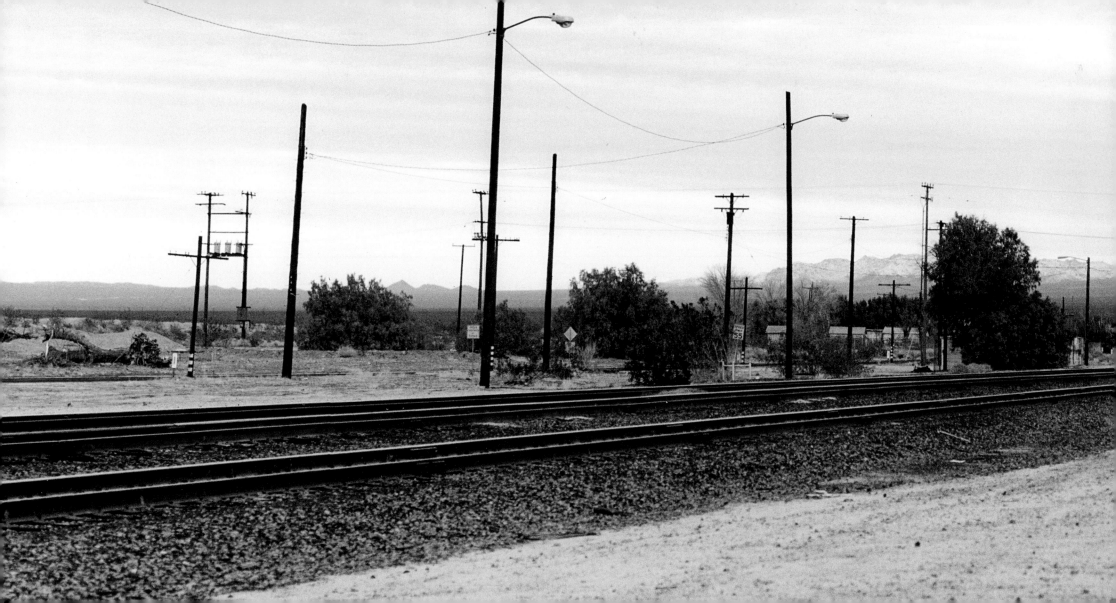

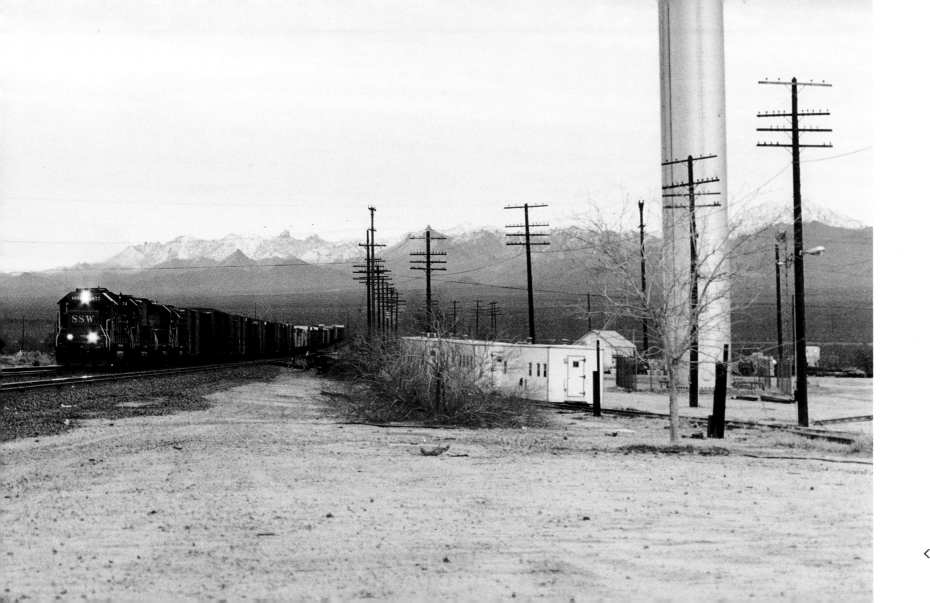

<KELSO CA 1997

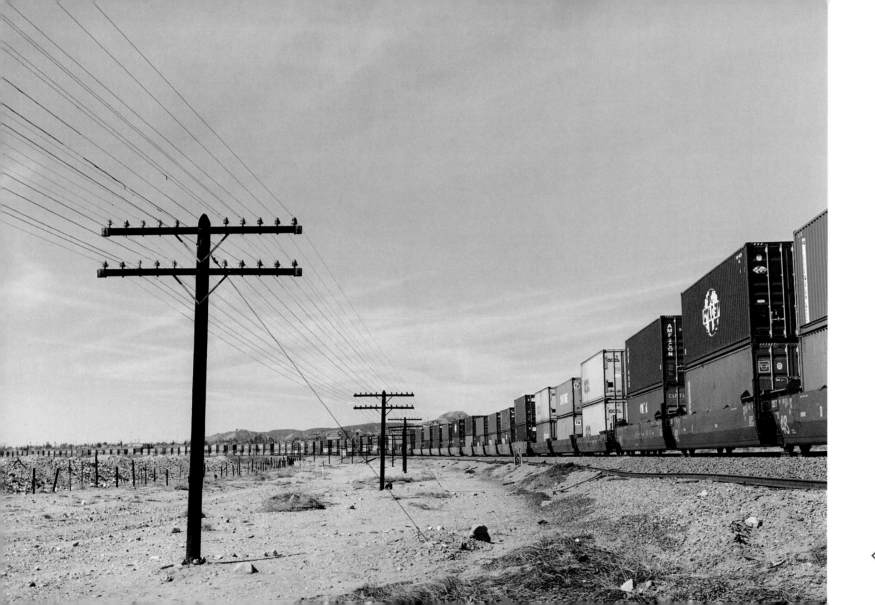

<.>BEAUMONT CA 2000

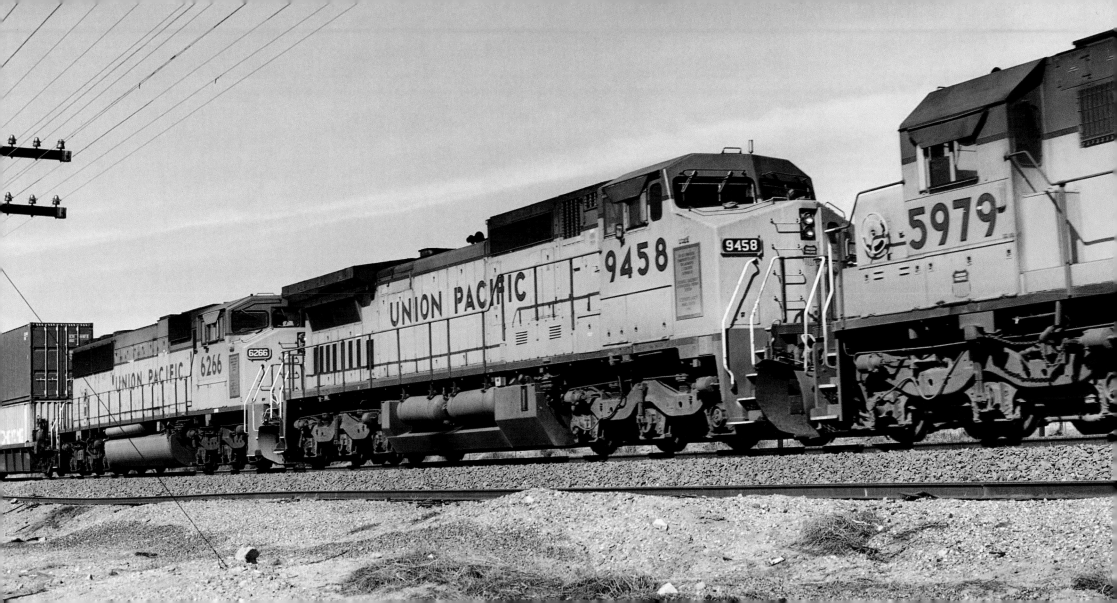

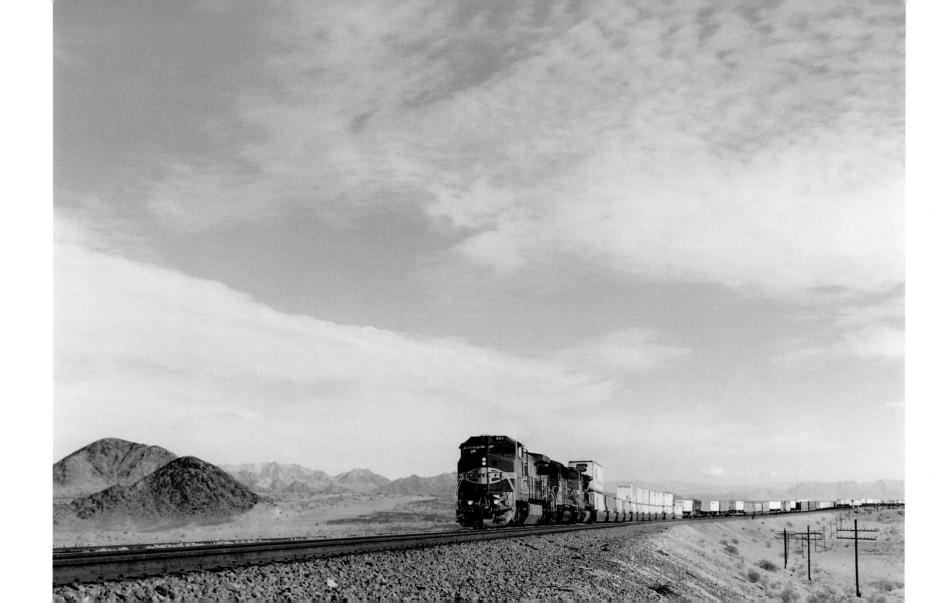

0018

<SIBERIA CA 1997

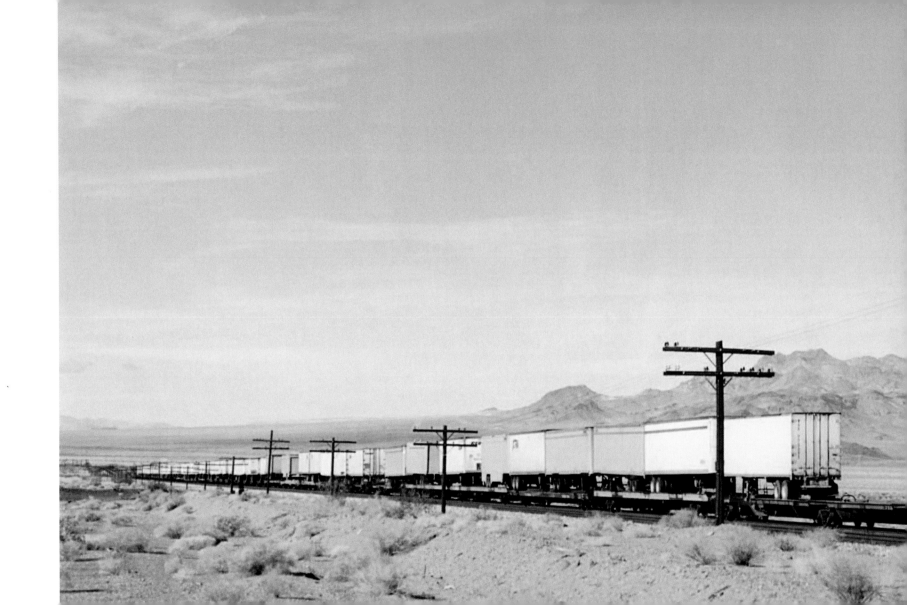

0020

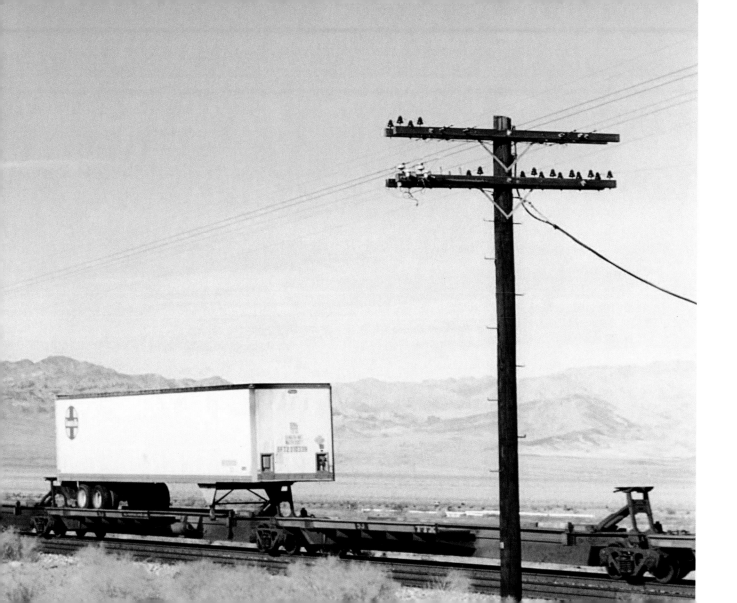

‹ASH HILL CA 1997

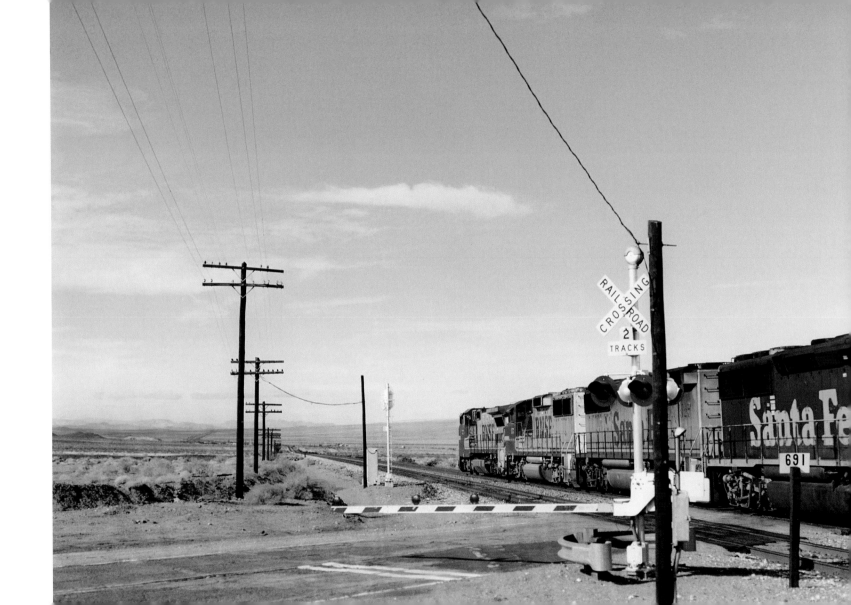

0022

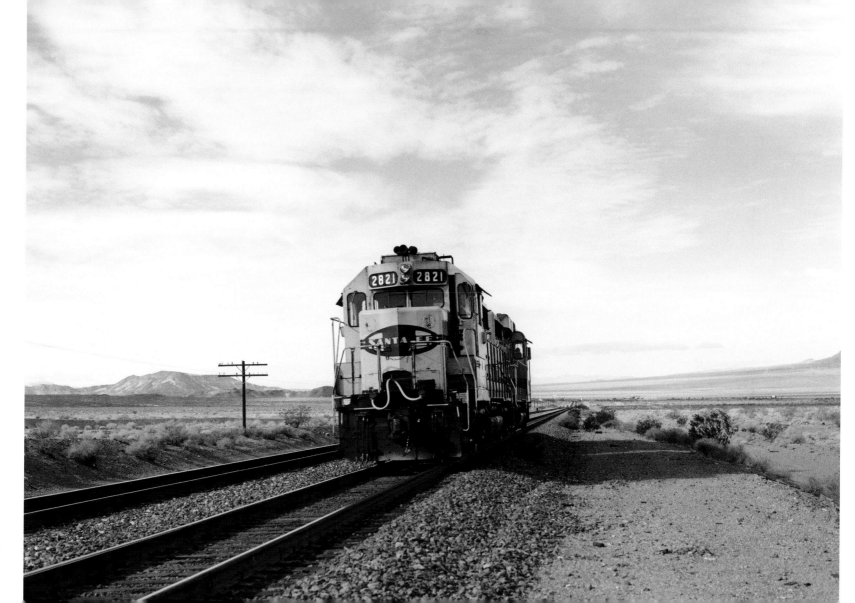

<.>ASH HILL CA 1997

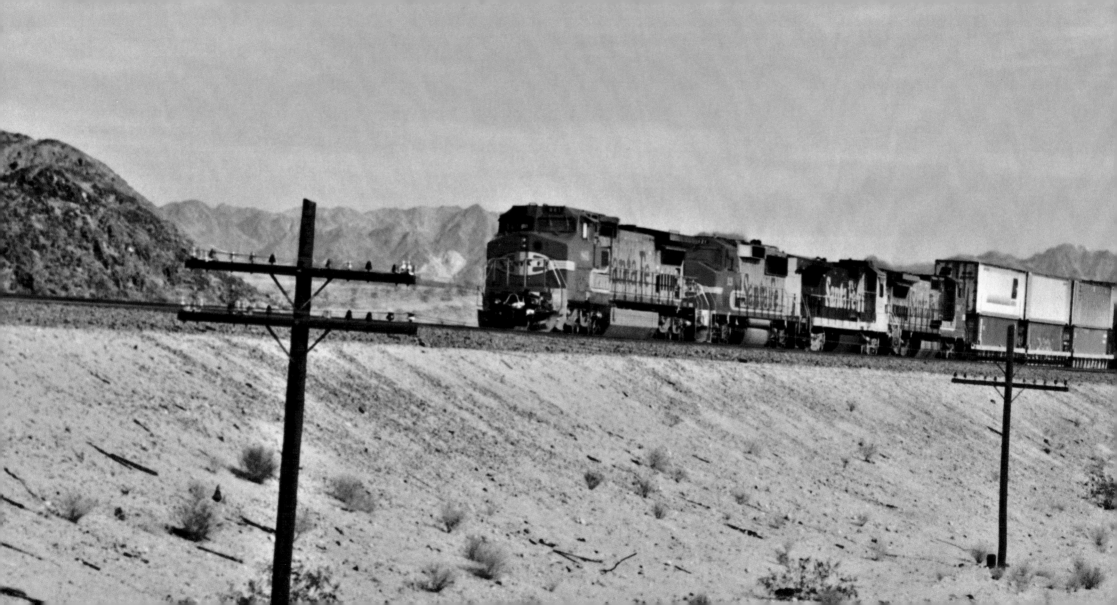

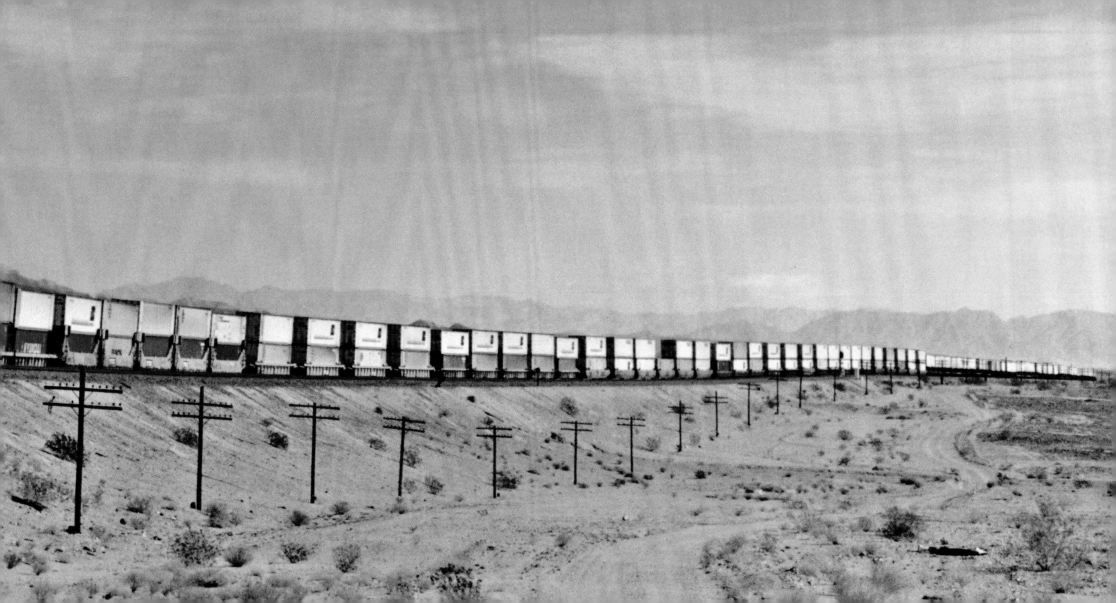

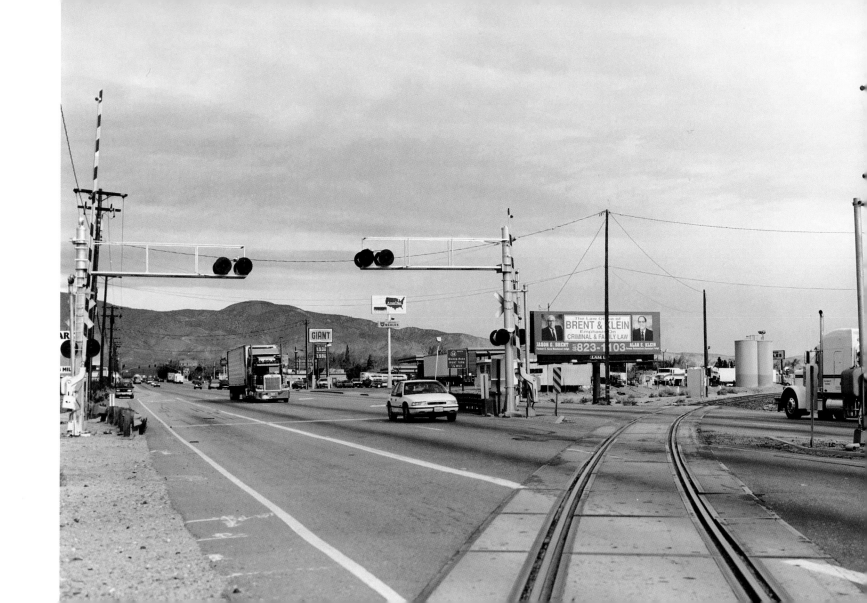

<SIBERIA CA 1997
>.>>MOJAVE CA 2000

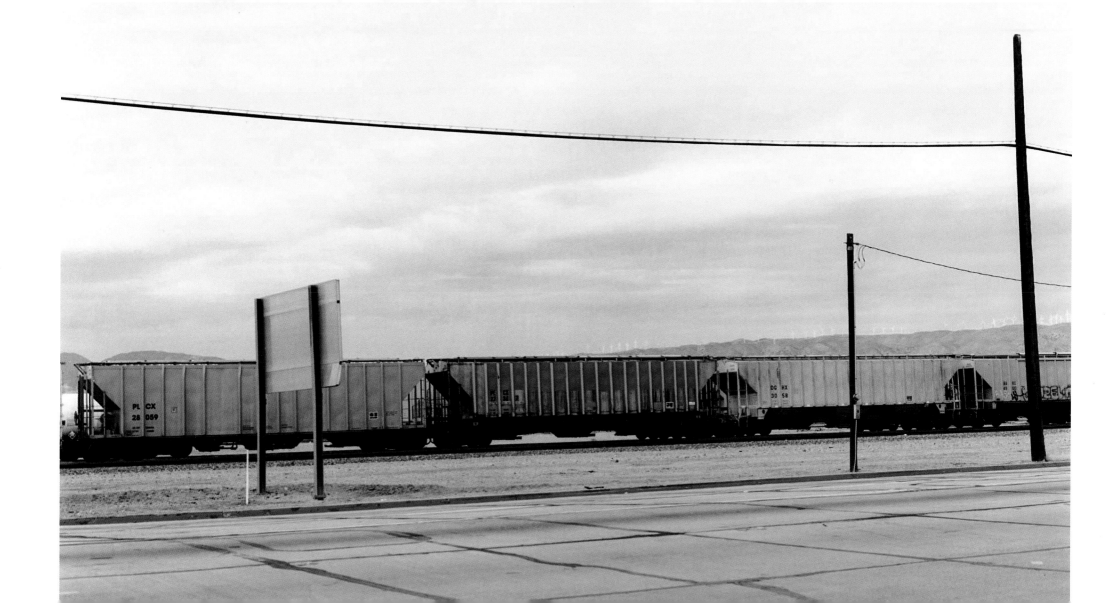

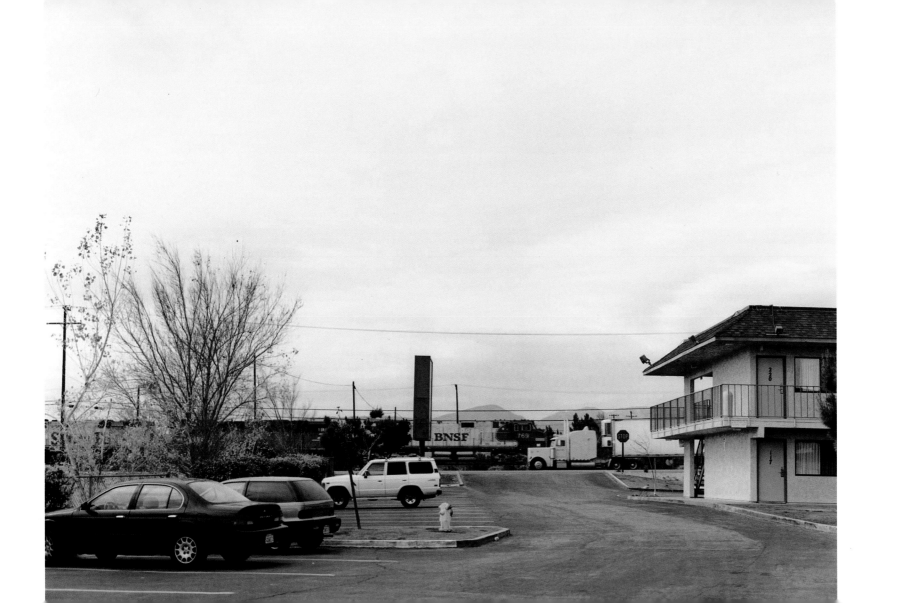

<MOJAVE CA 2000

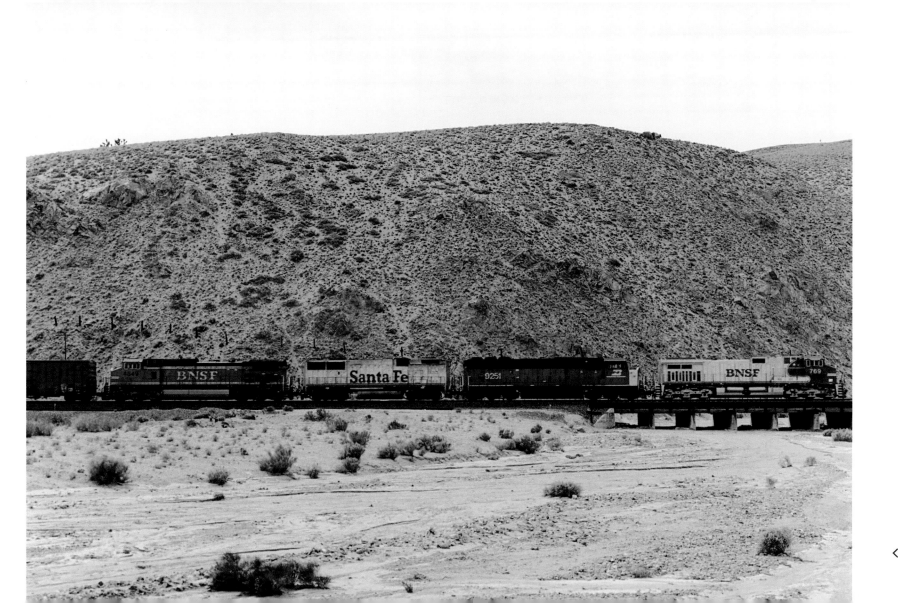

<WARREN CA 2000

SOME TRAINS IN AMERICA: TEXAS

>MCNEIL TX 2001

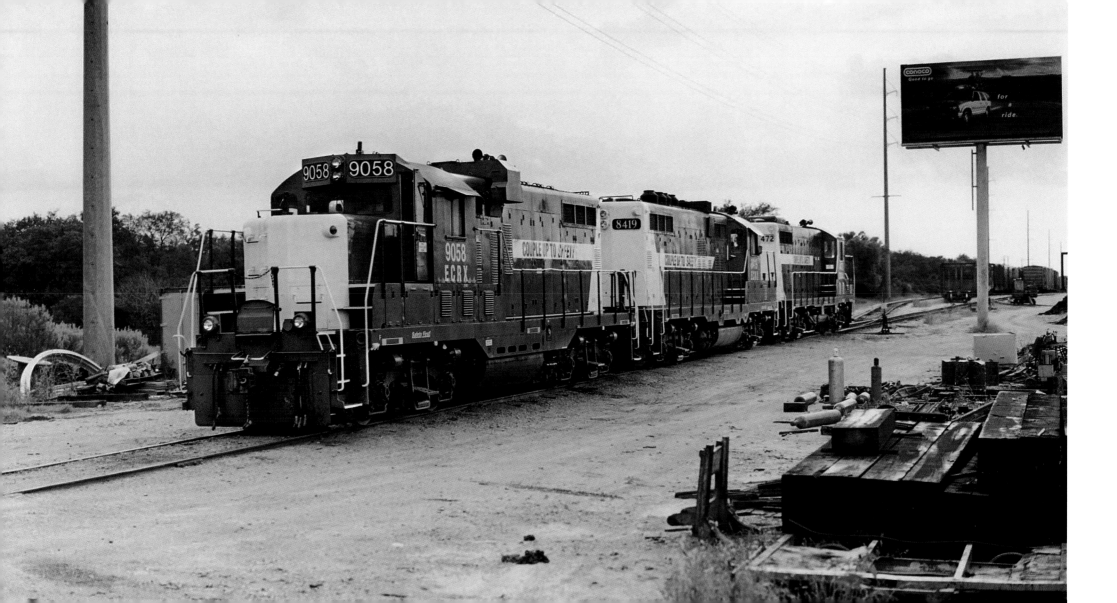

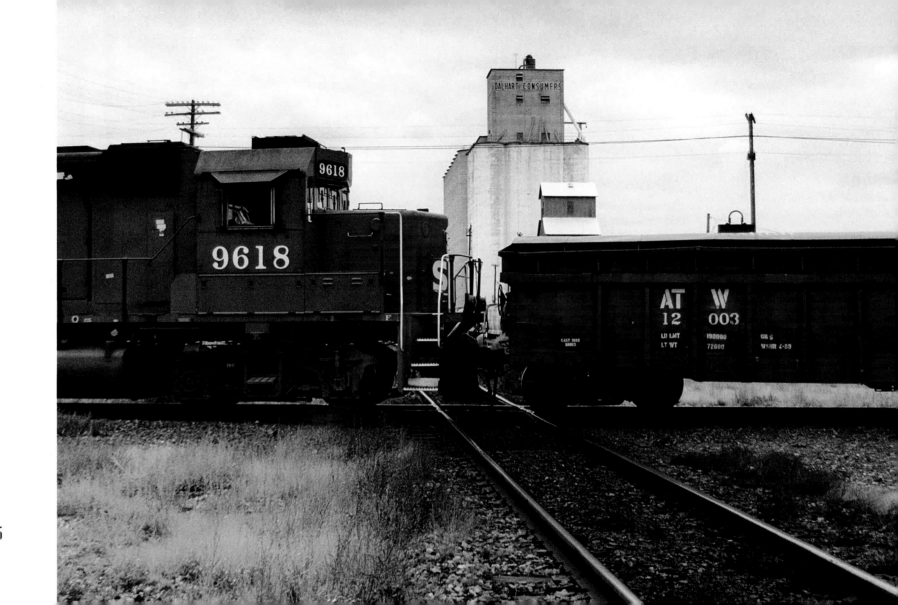

>DALHART TX 1995
>>AUSTIN TX 2001

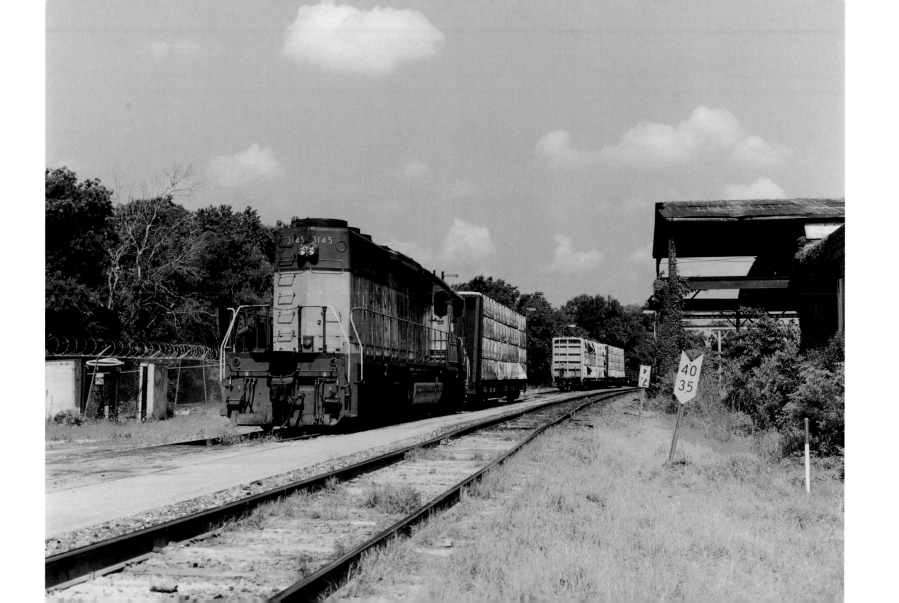

0033

>ROSENBERG TX 2001

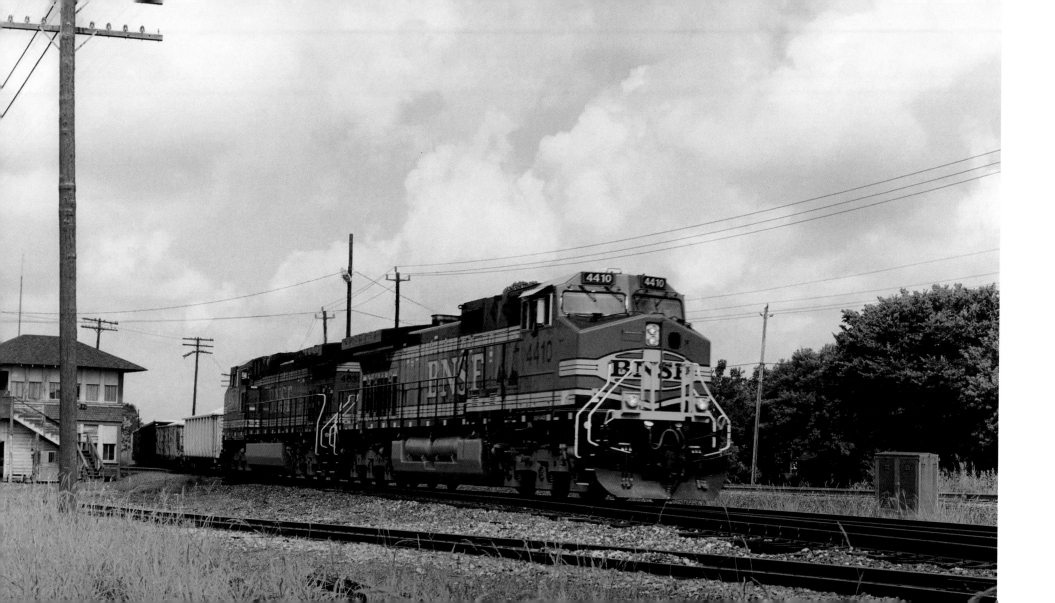

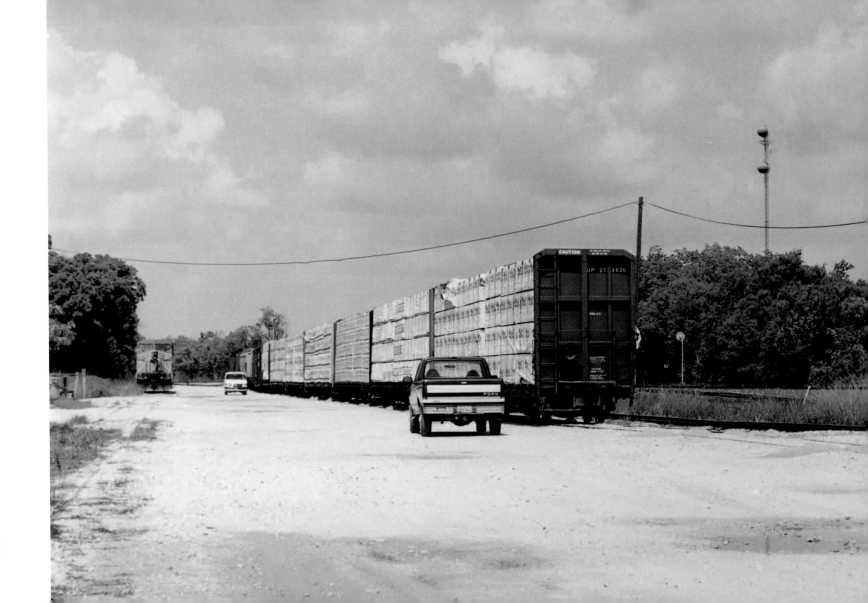

>ROSENBERG TX 2001

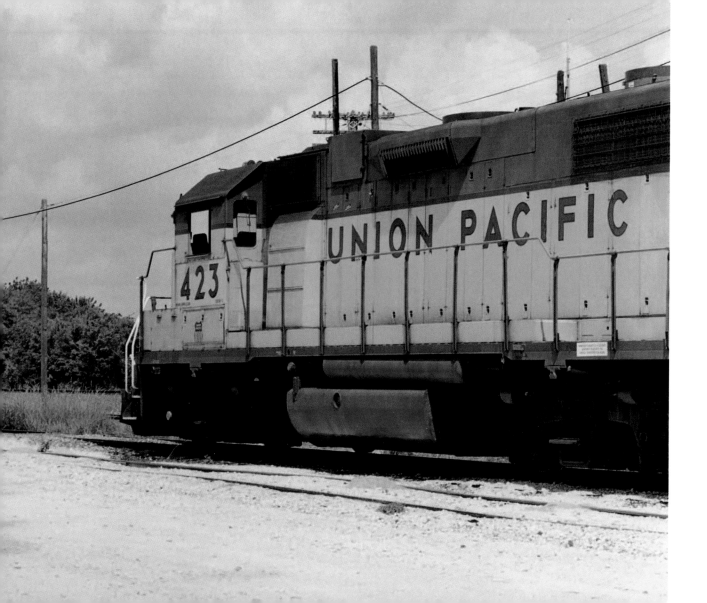

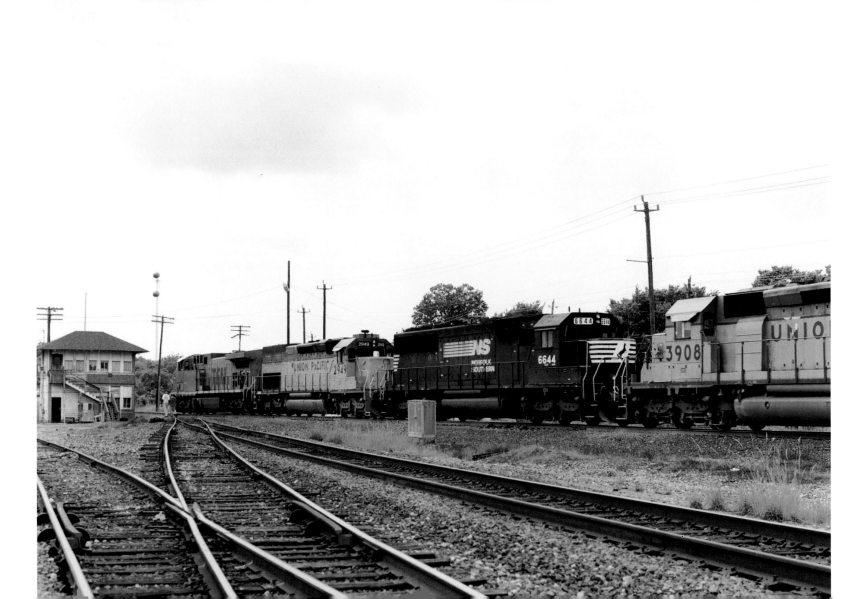

>ROSENBERG TX 2001

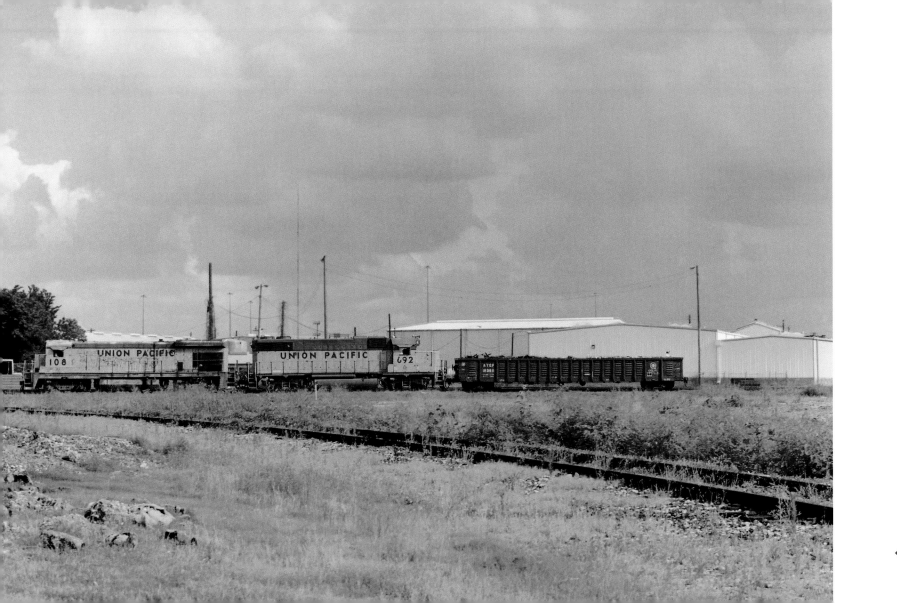

<HOUSTON TX 2001

0040

SOME TRAINS IN AMERICA: APPALACHIA

>PARIS KY 1995

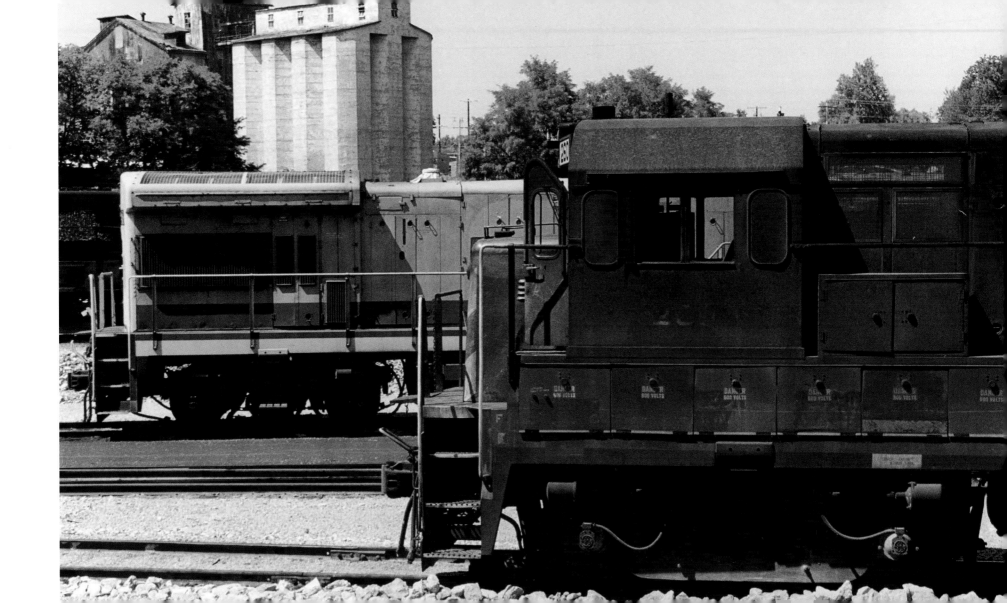

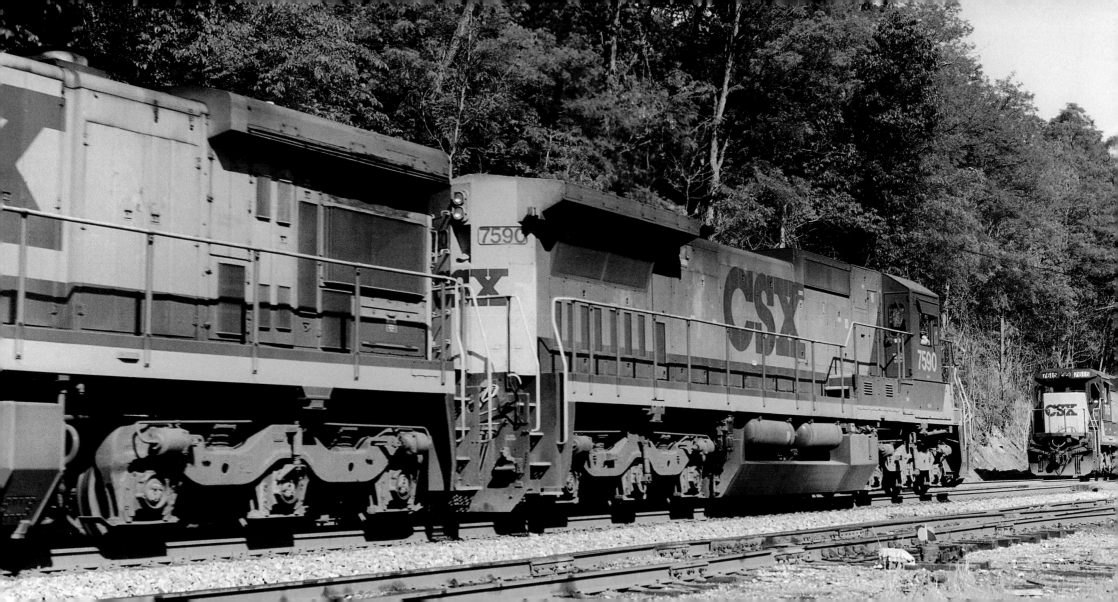

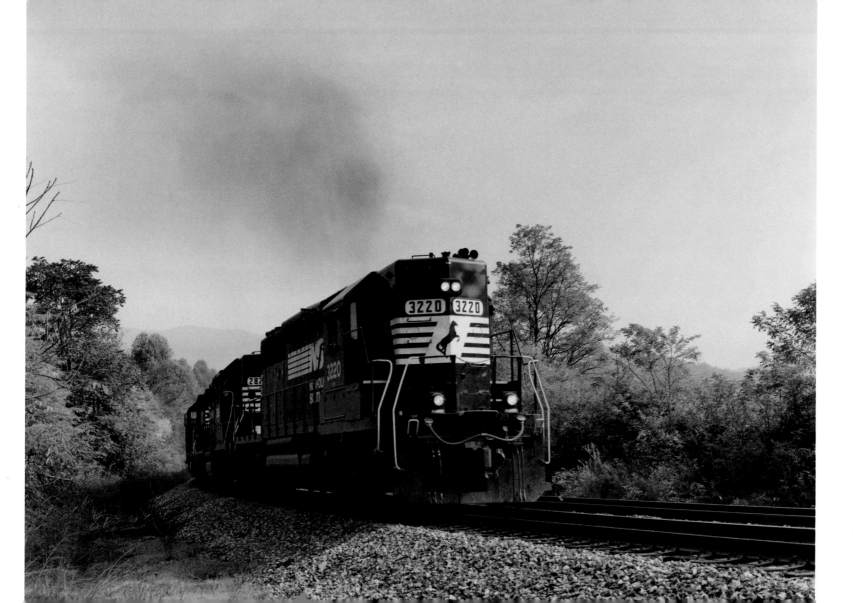

<<THURMOND WV 1996
<ELLETT VA 1997

>ELLETT VA 1997

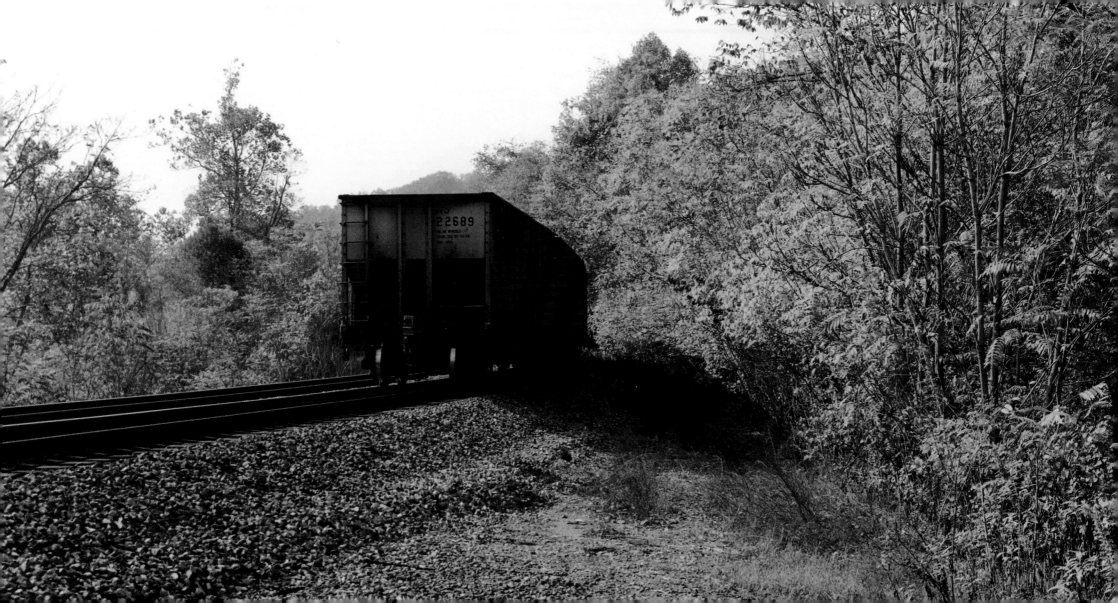

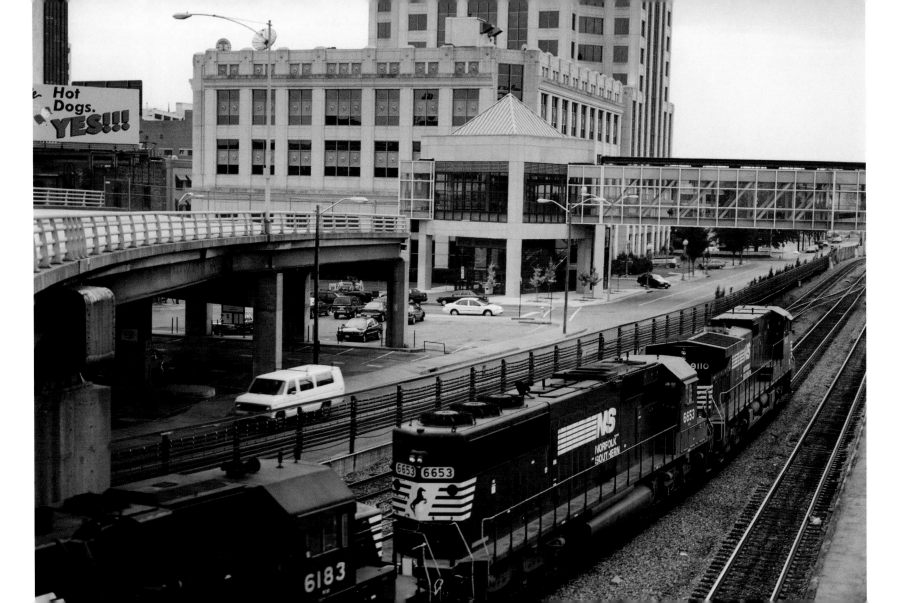

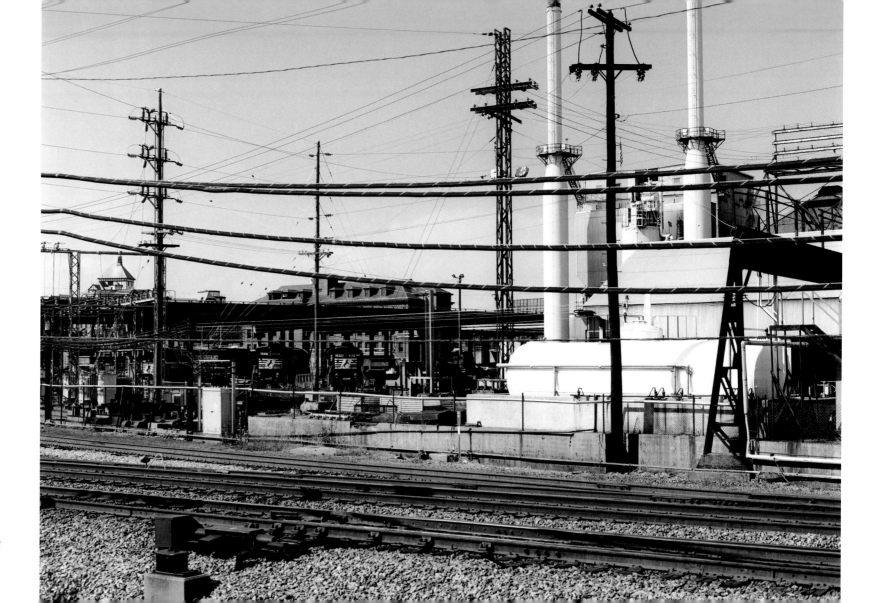

<.>ROANOKE VA 1997

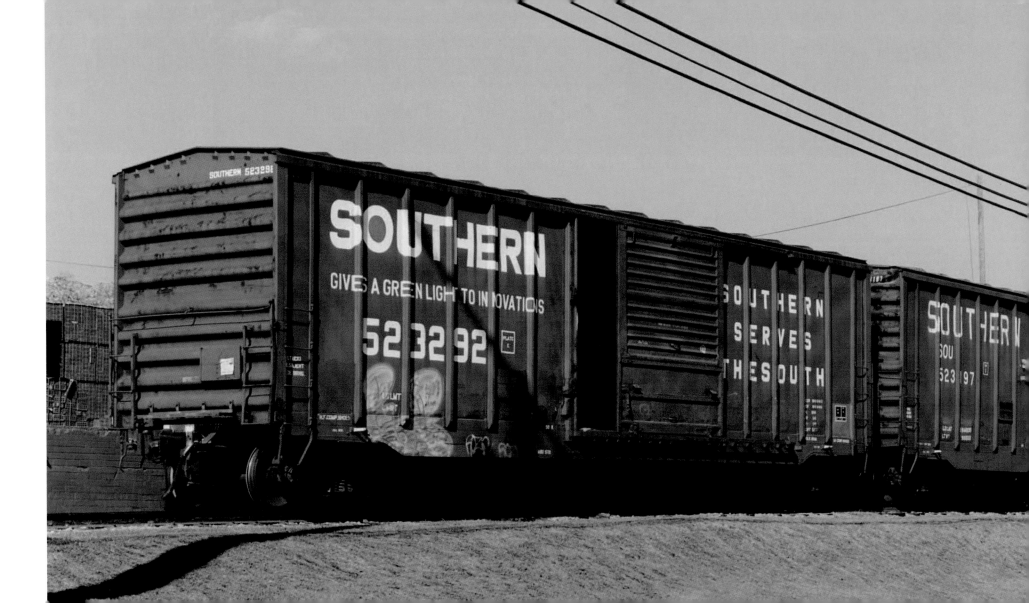

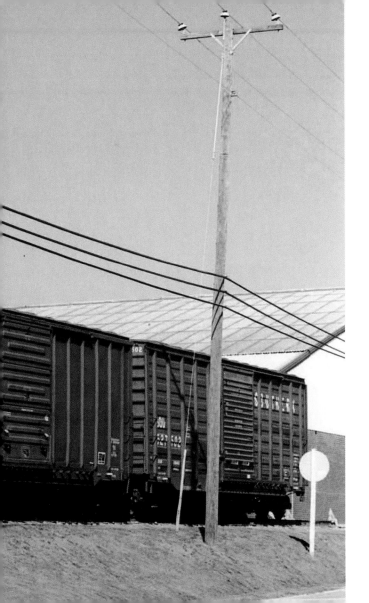

<WEBSTER VA 1997

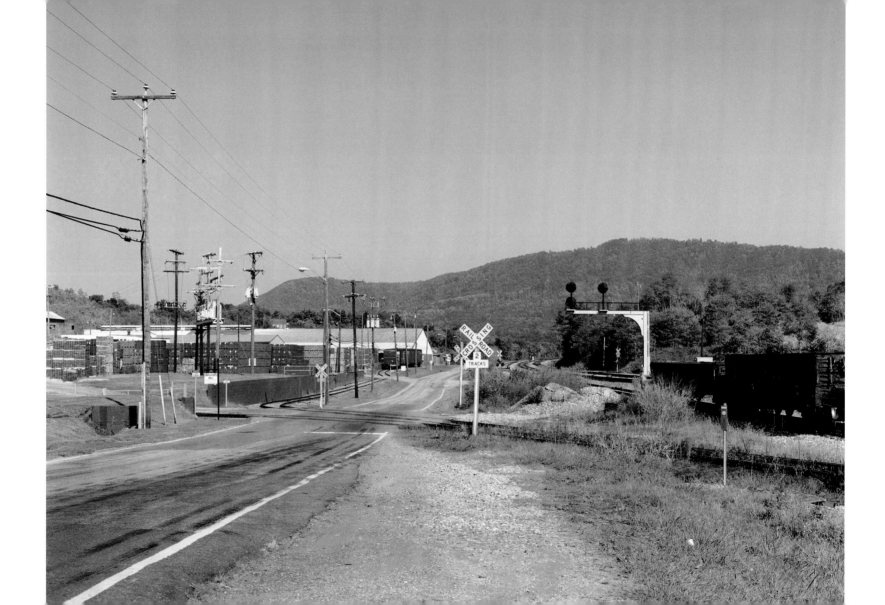

0050

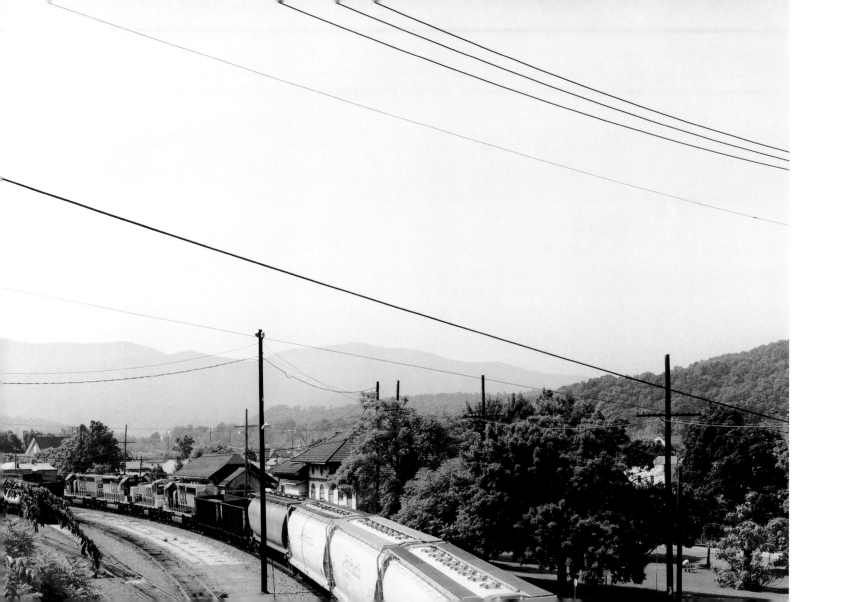

<<WEBSTER VA 1997
<COVINGTON VA 1996
>BUCHANAN VA 1997

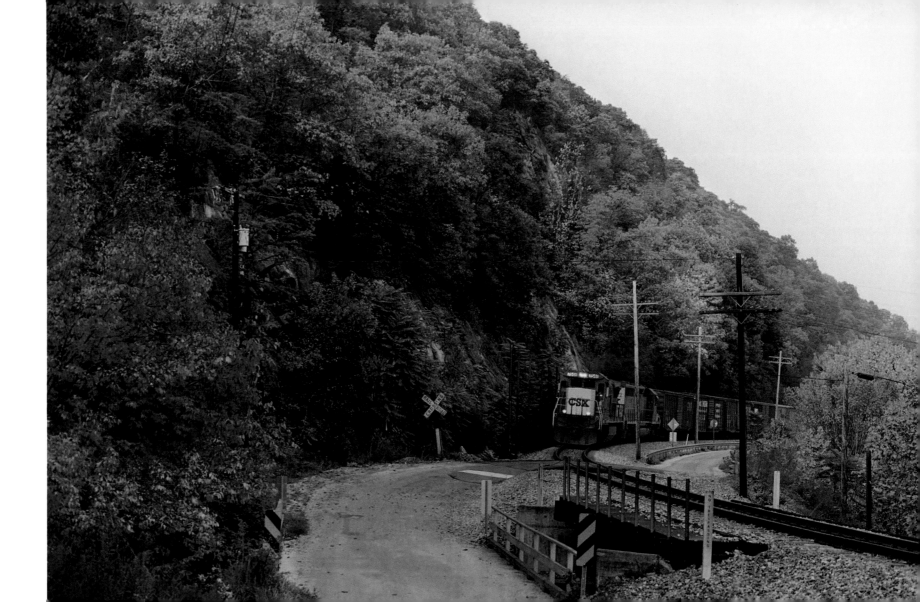

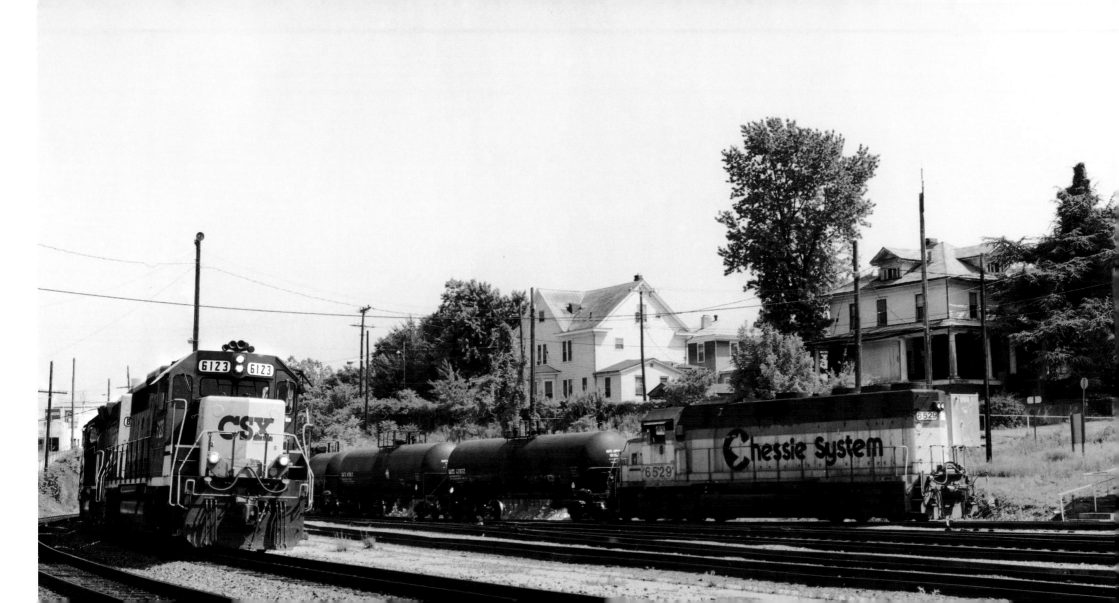

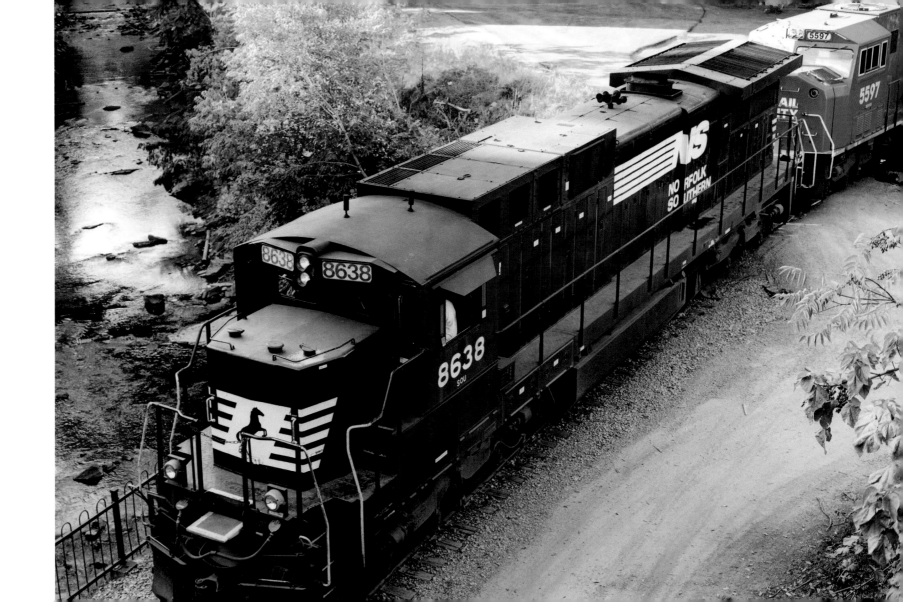

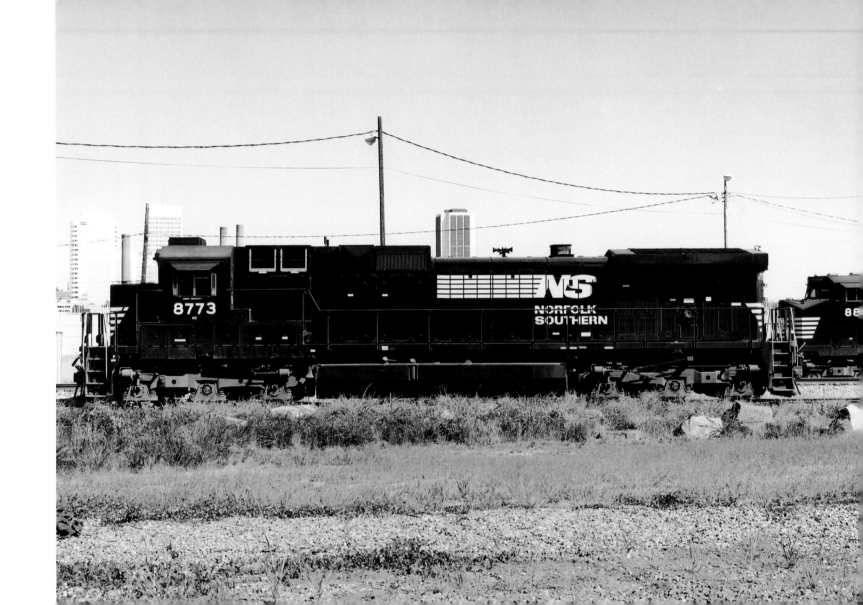

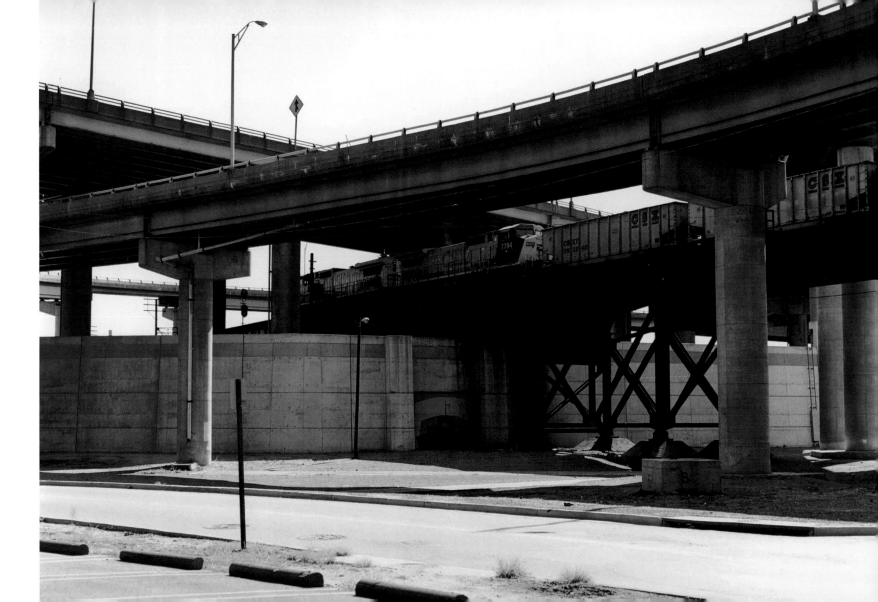

>RICHMOND VA 1997

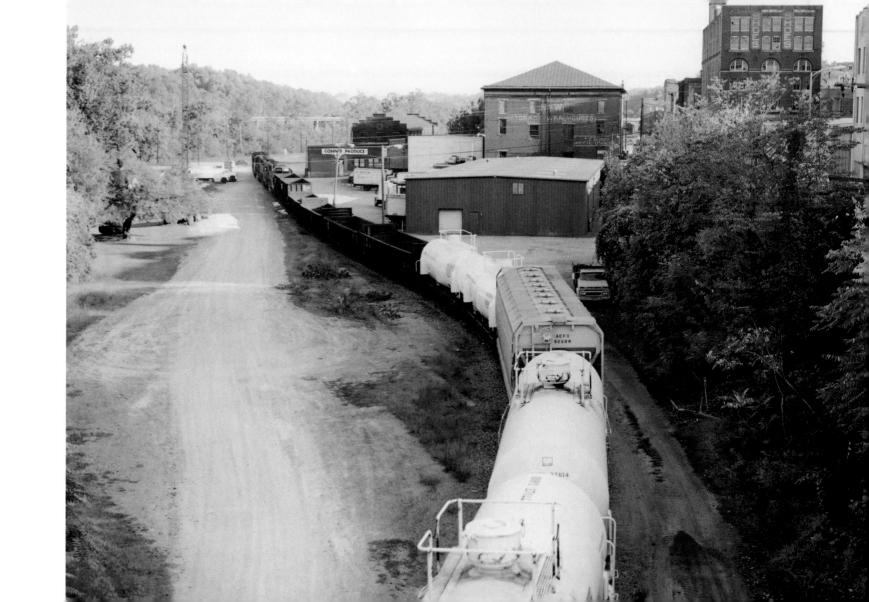

>LYNCHBURG VA 1997

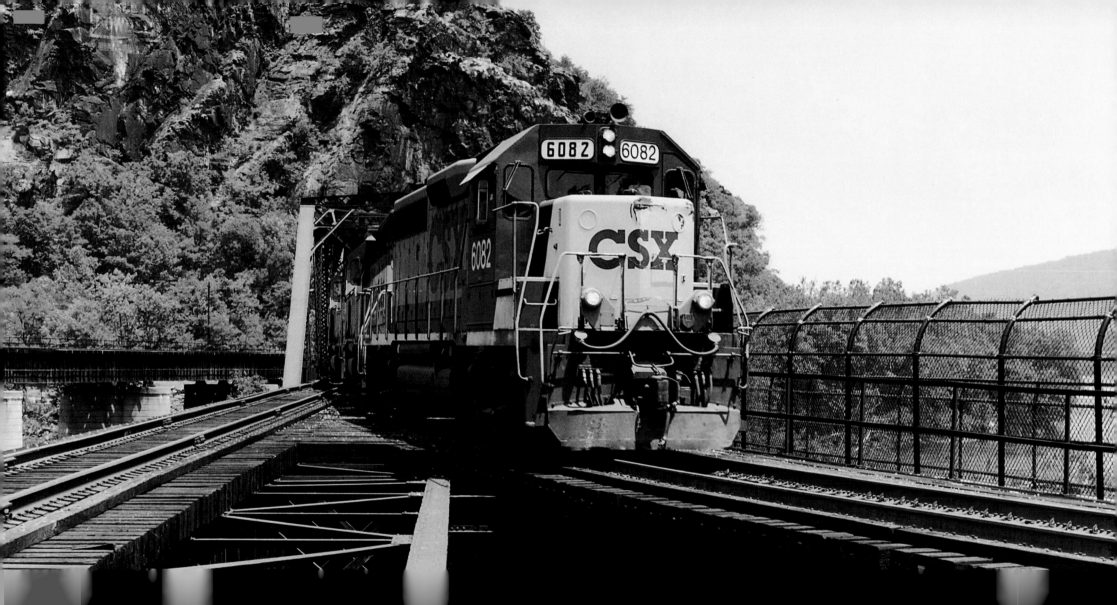

<HARPERS FERRY WV 1996
>BURNSIDE KY 1996
>>GORE VA 1997

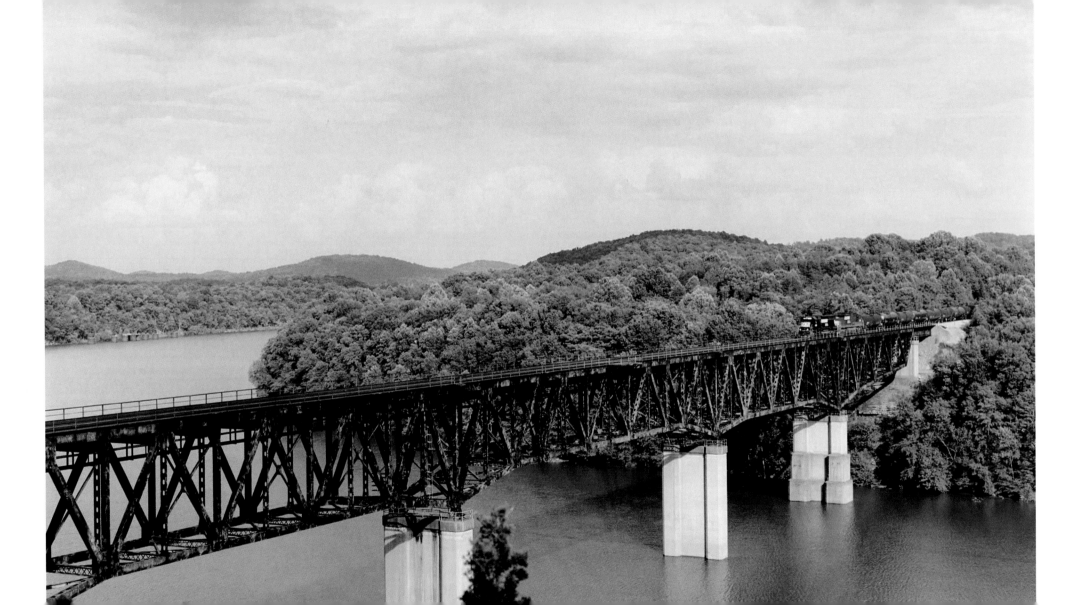

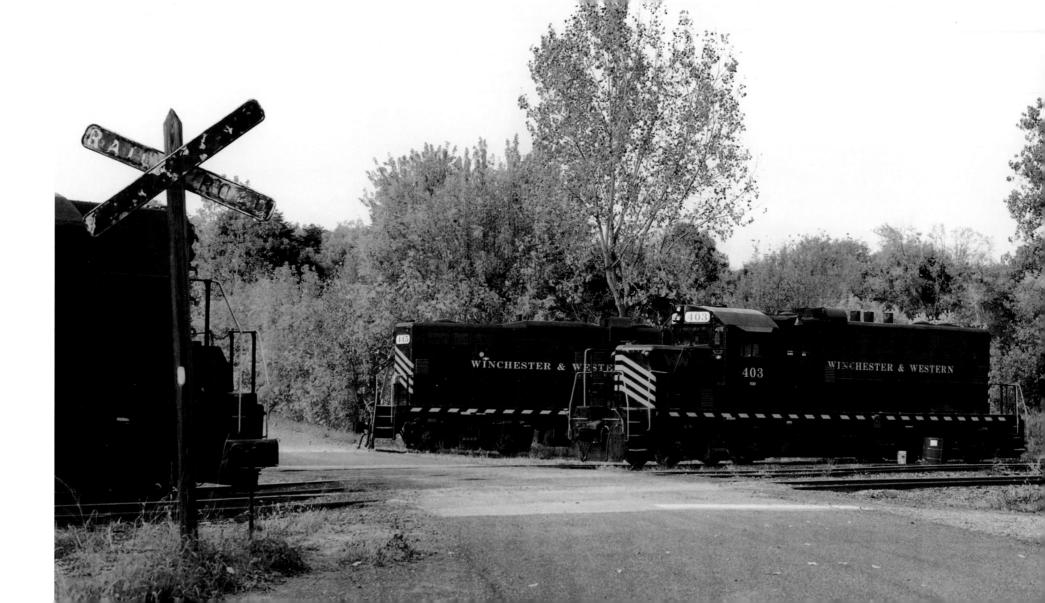

0062

SOME TRAINS IN AMERICA: NORTHEAST

>CRESSON PA 1998

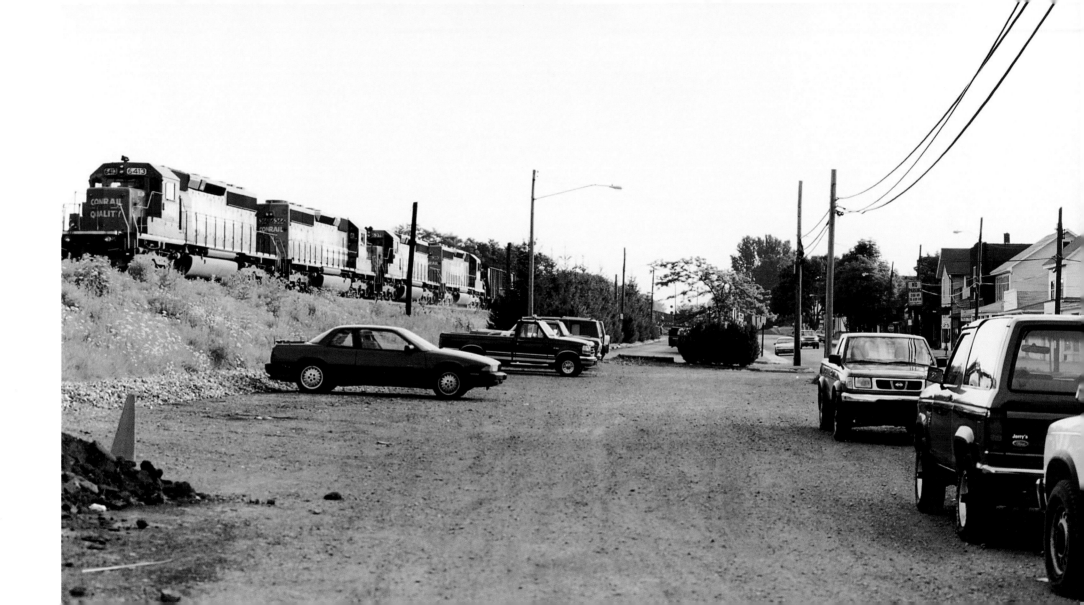

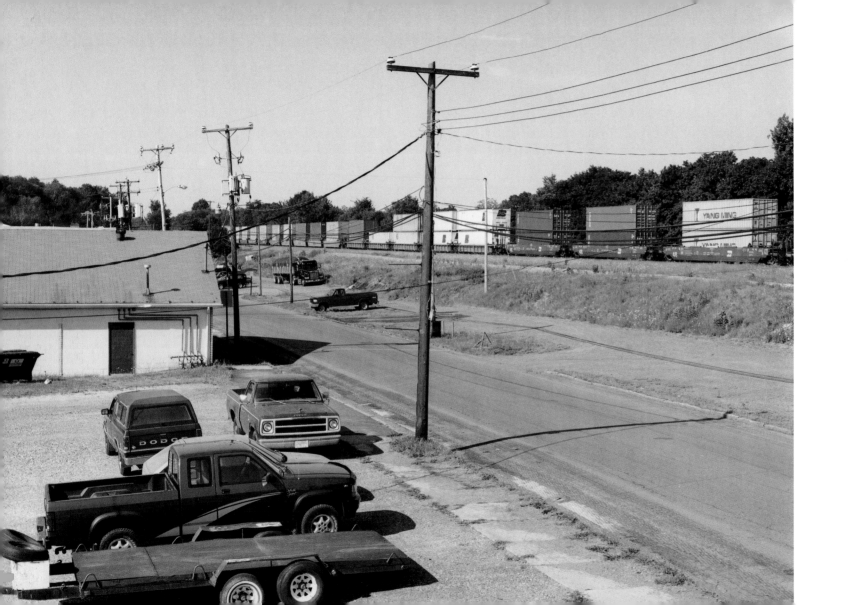

<.>CRESSON PA 1998

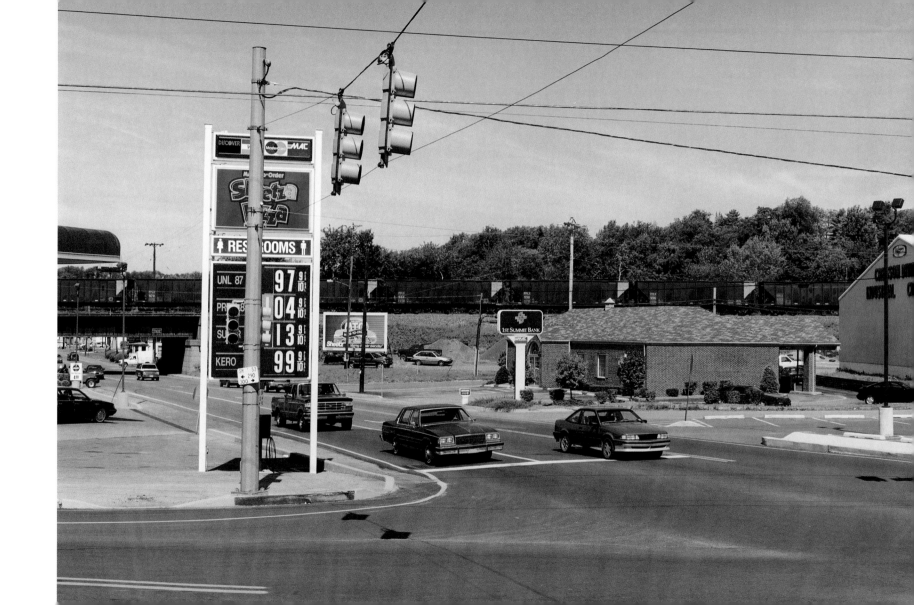

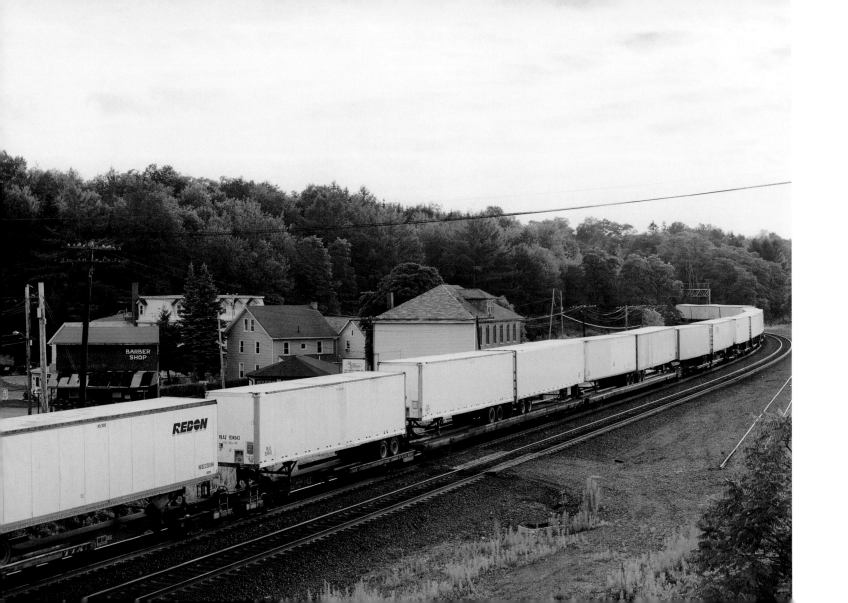

<.>GALLITZIN PA 1998

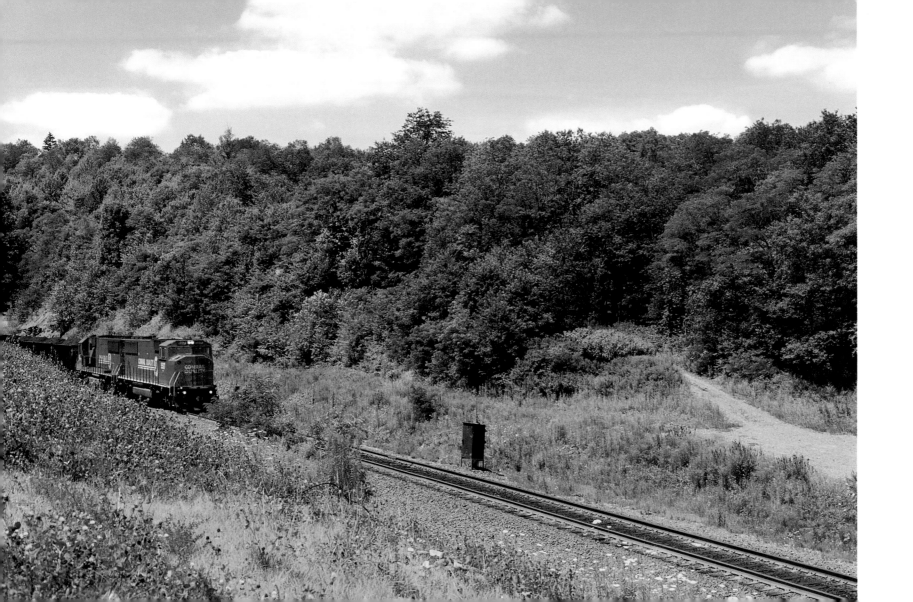

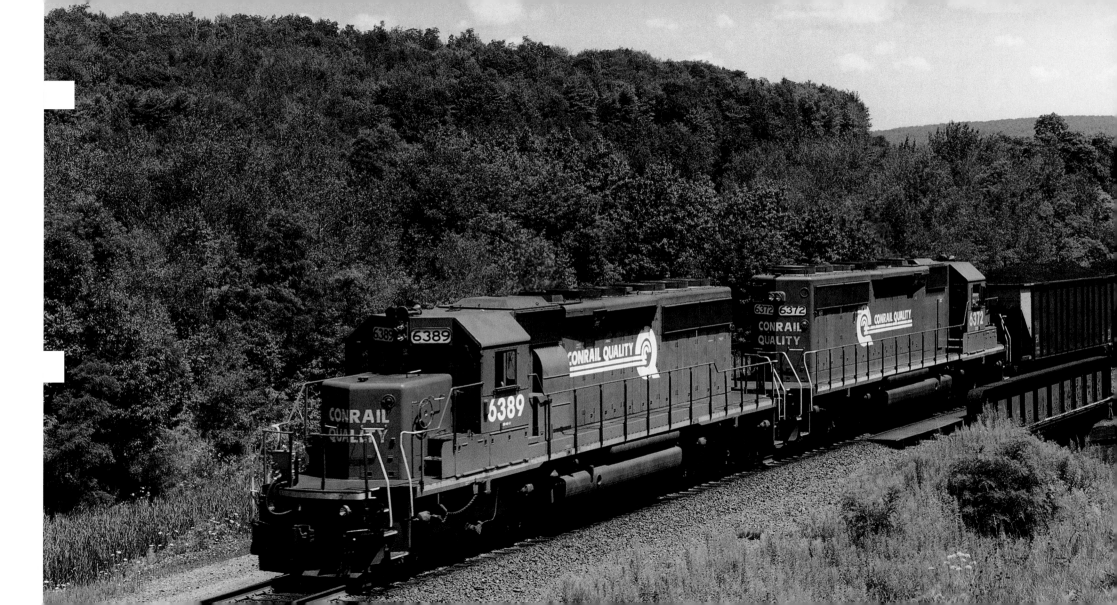

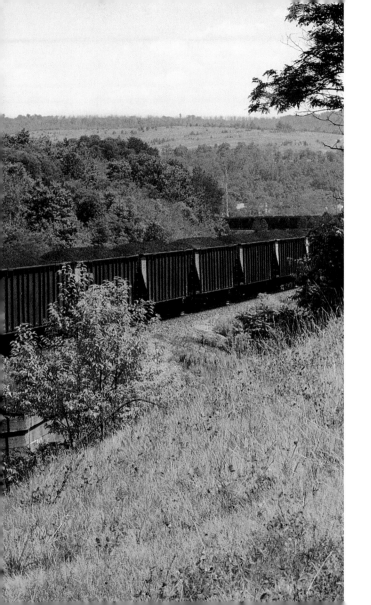

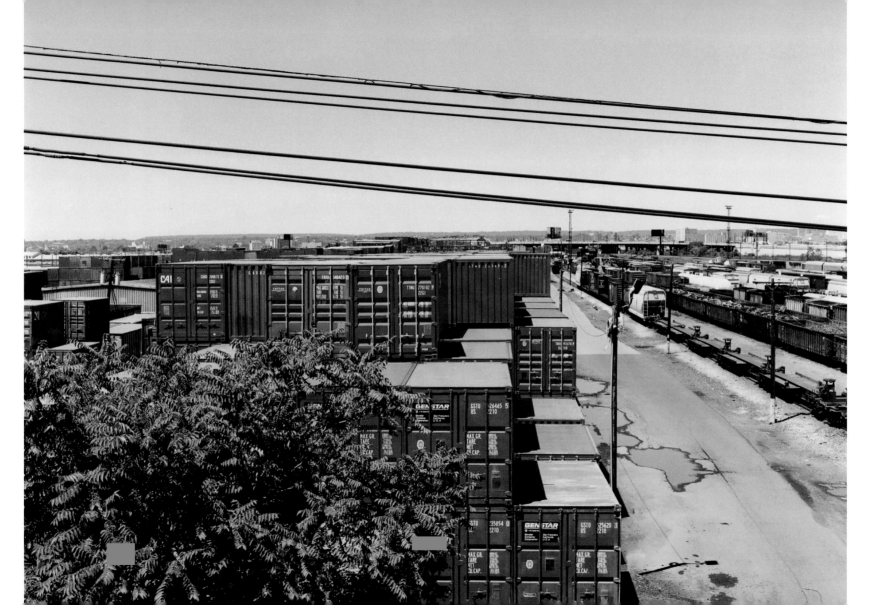

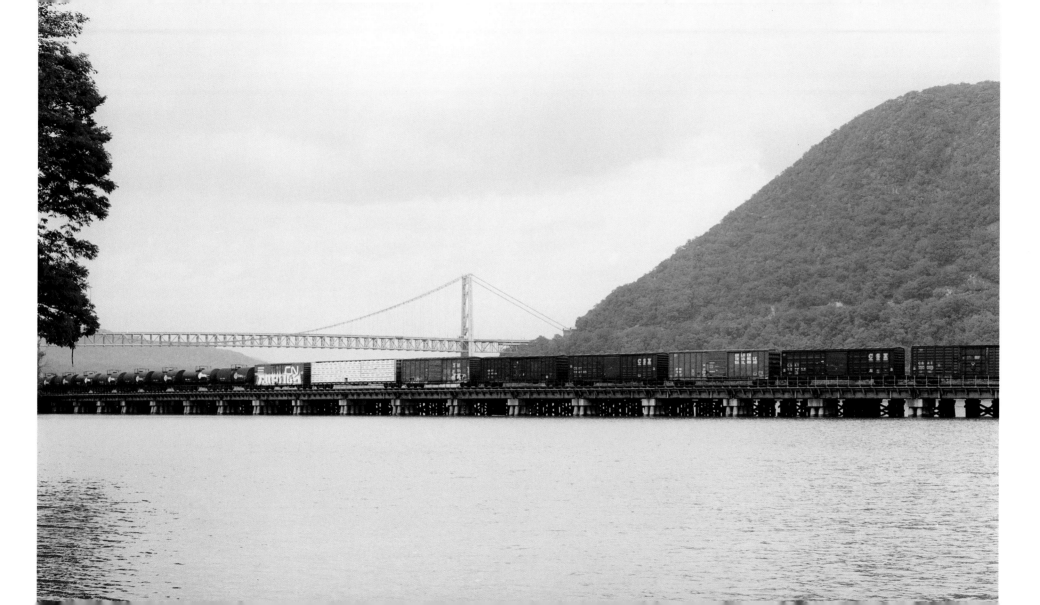

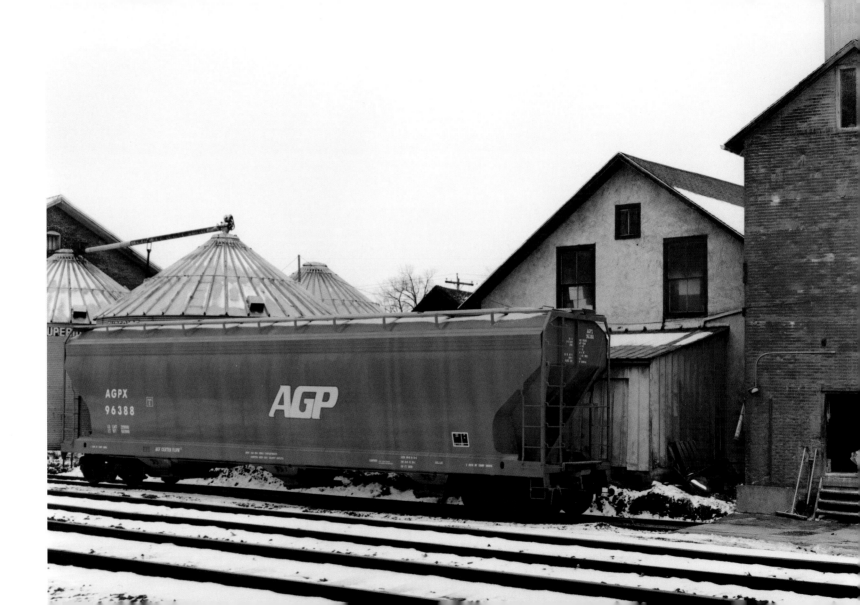

<AVON NY 1997
>ROCHESTER NY 1997
>>SELKIRK NY 1997

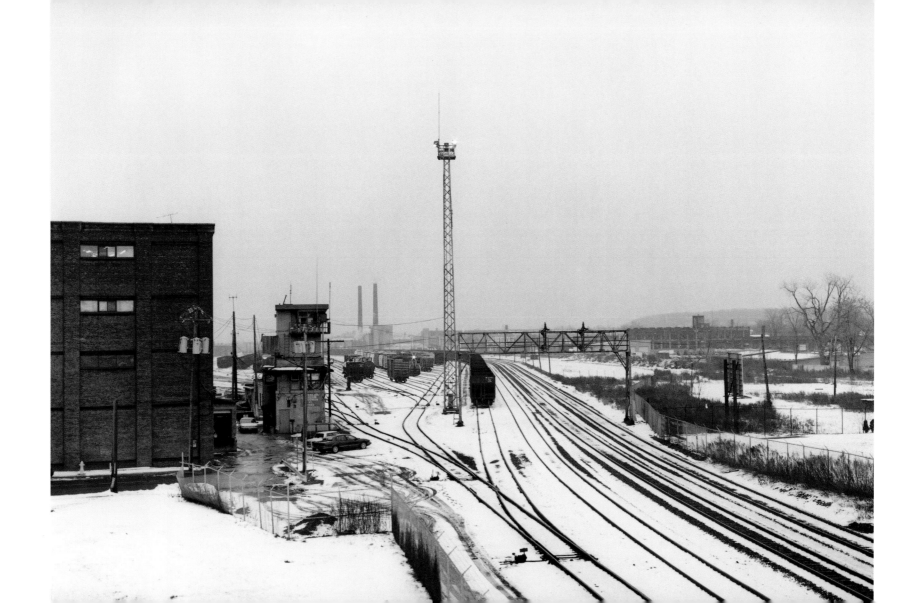

0074

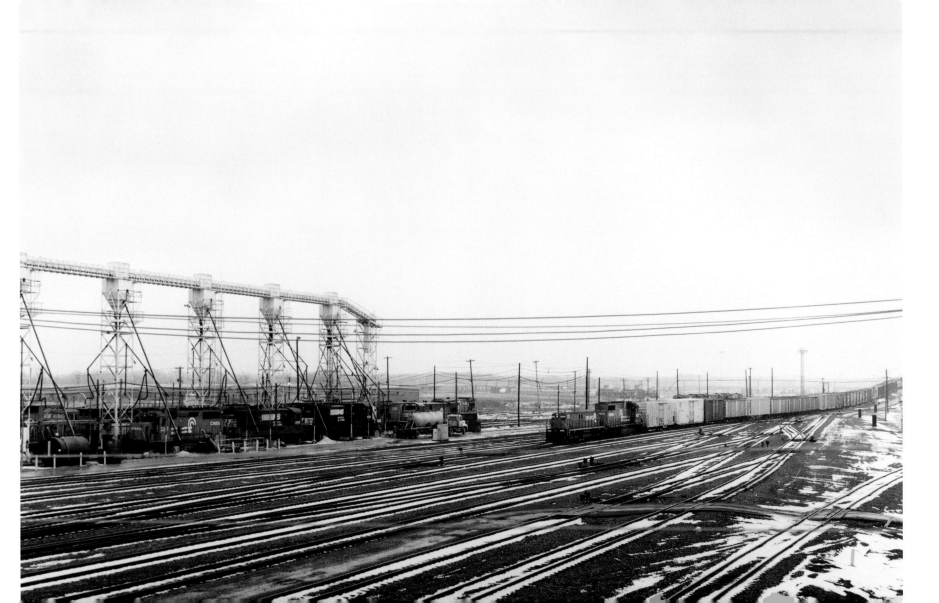

>.>>SELKIRK NY 1997
>>>ALBANY NY 1997

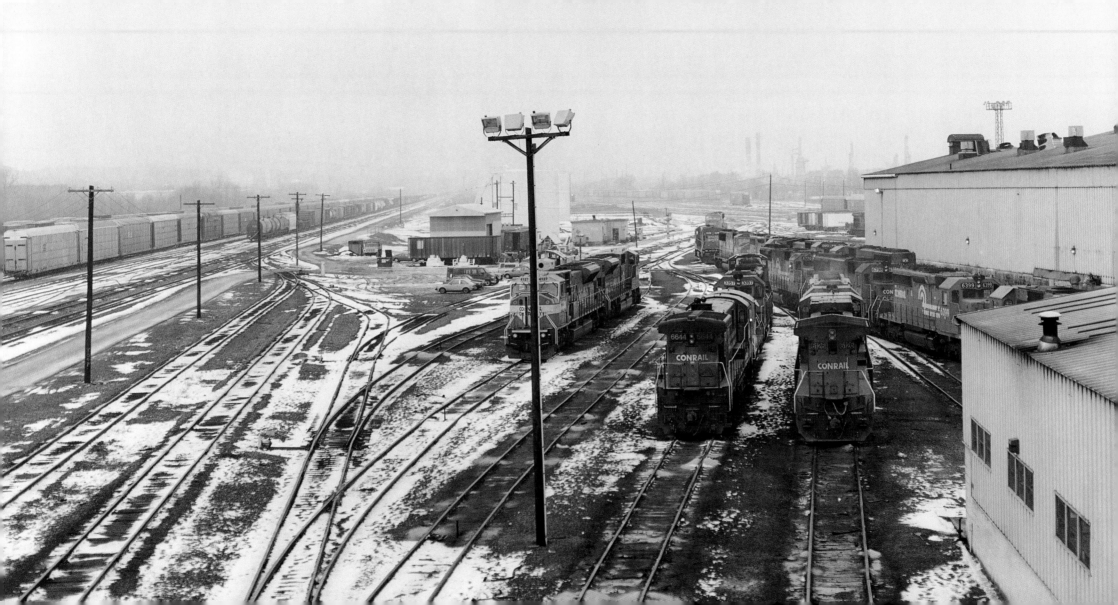

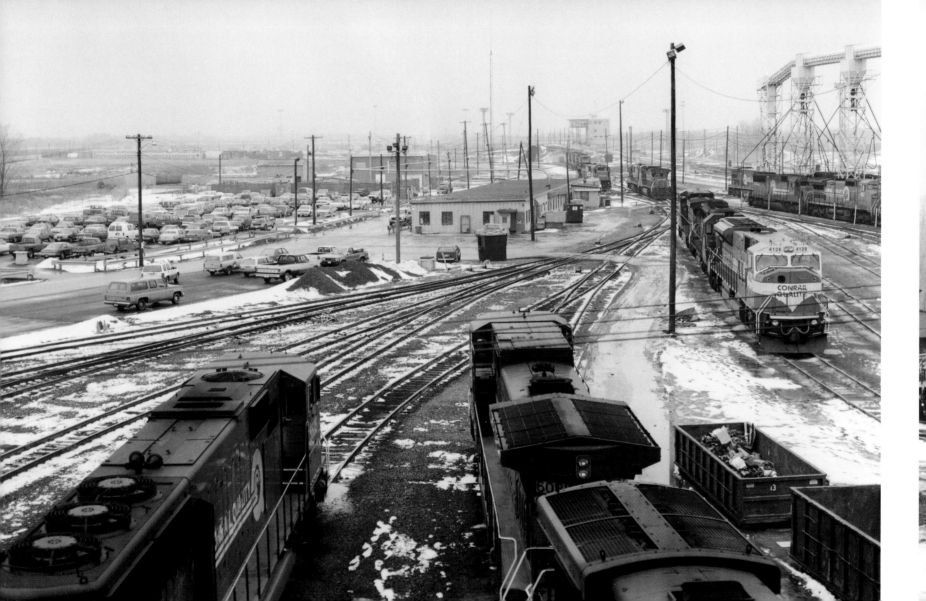
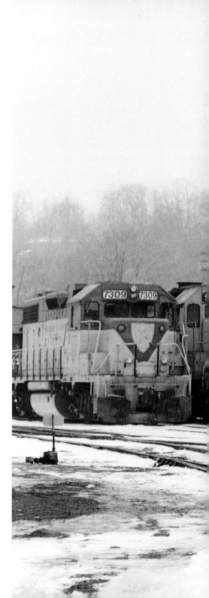

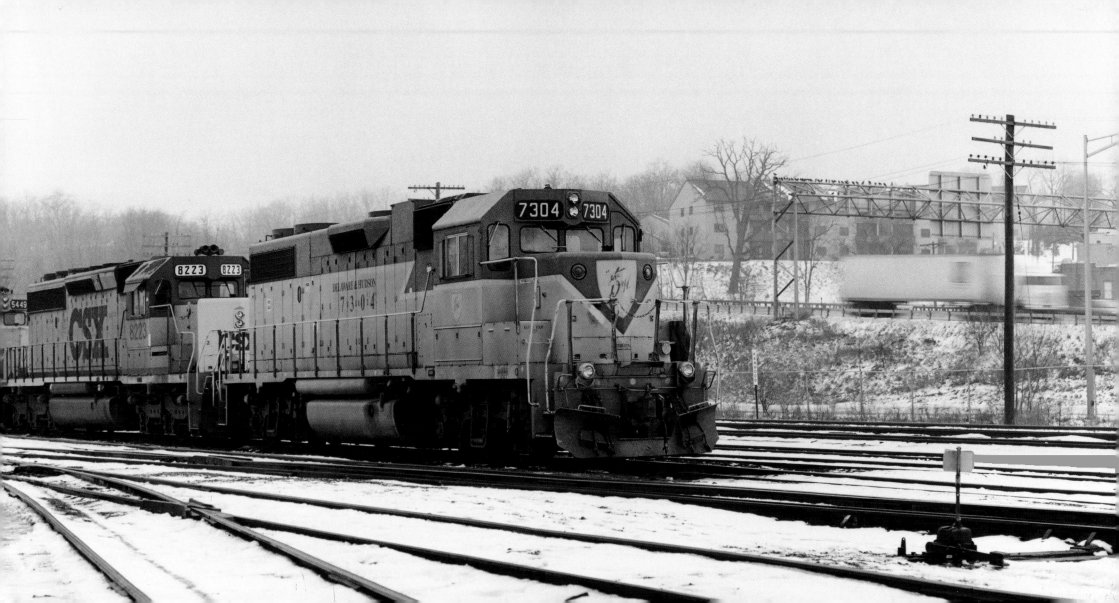

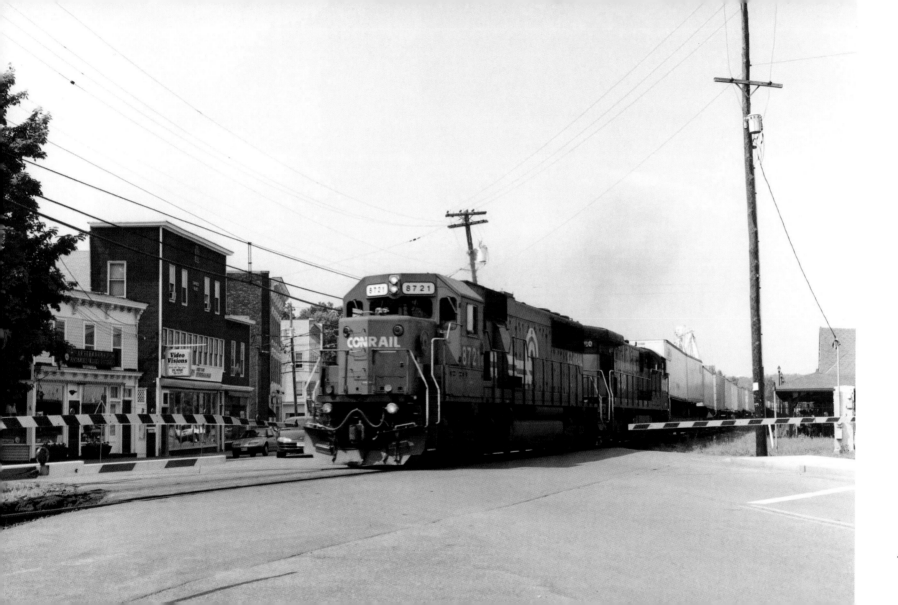

<CHATHAM NY 2000

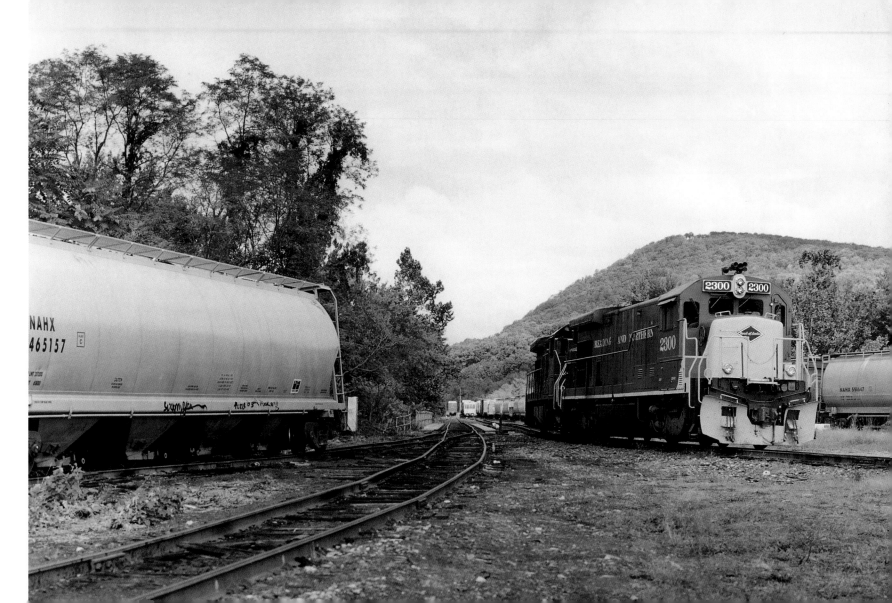

>PITTSTON PA 2000

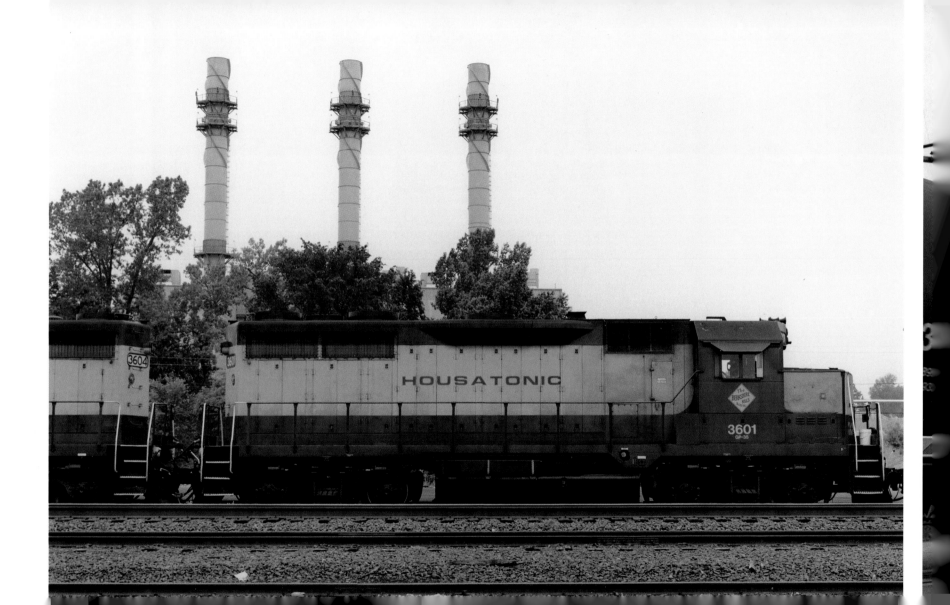

0082

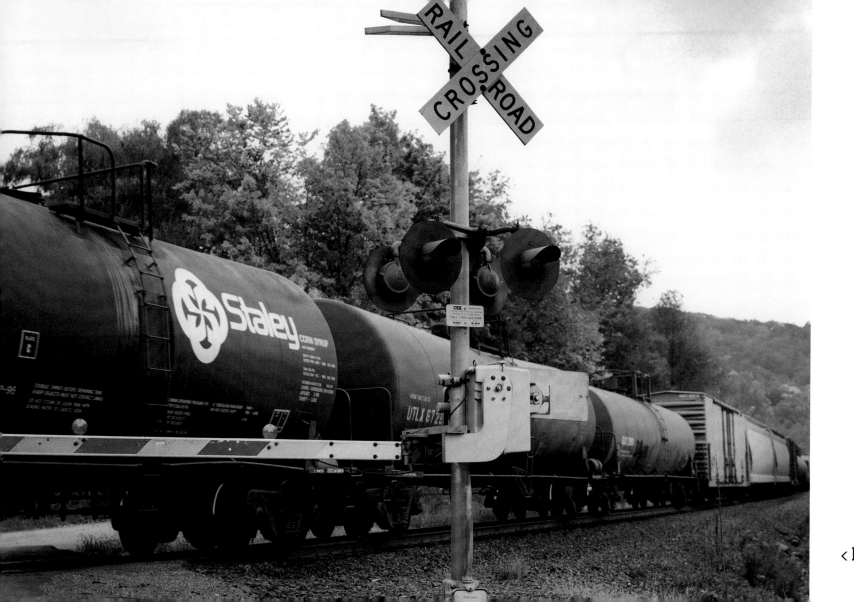

<< PITTSFIELD MA 2000
< EAST CHATHAM NY 1999

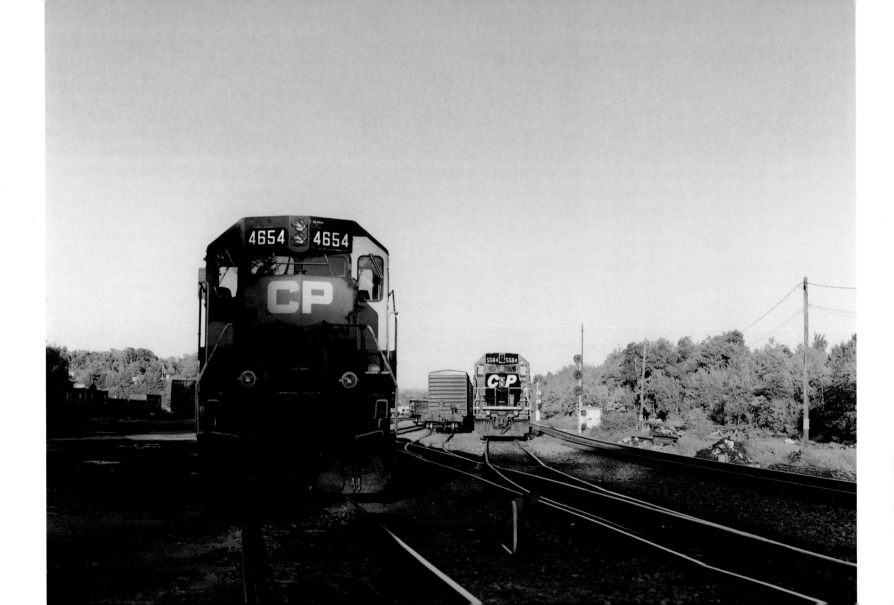

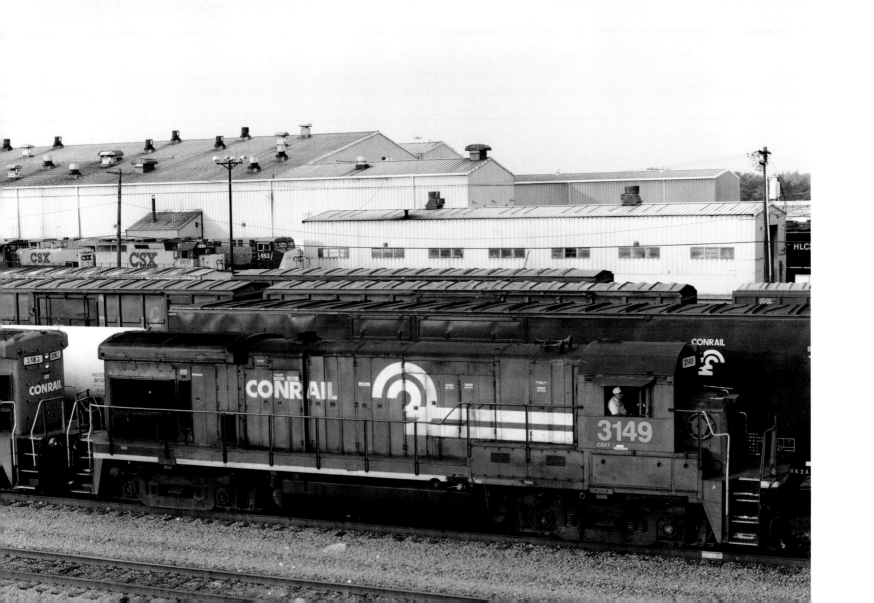

<<TAYLOR PA 1999
<SELKIRK NY 1999

>TAYLOR PA 2000

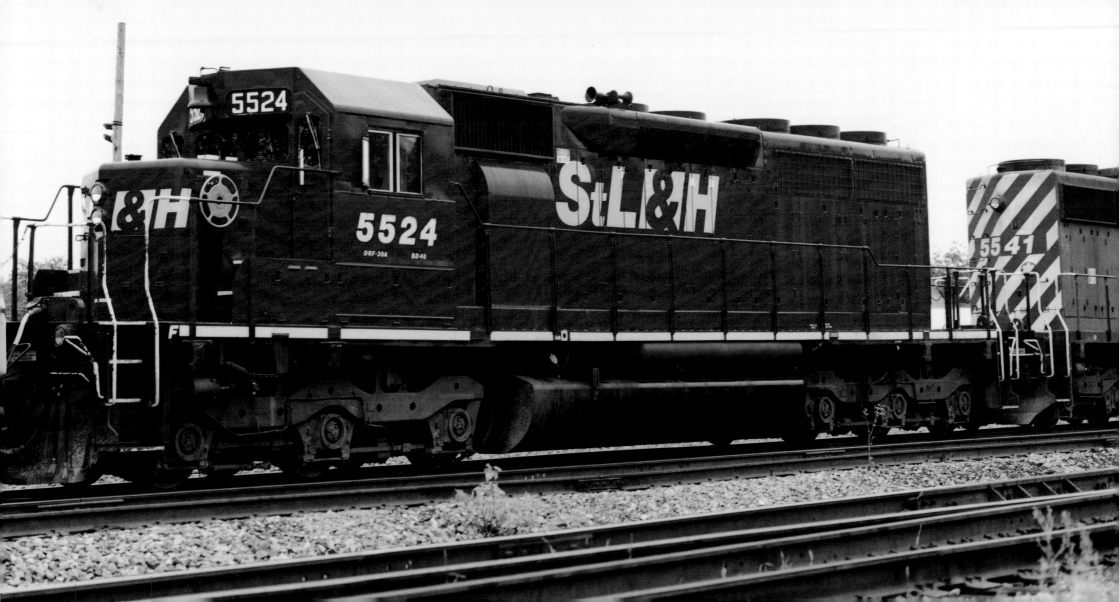

0088

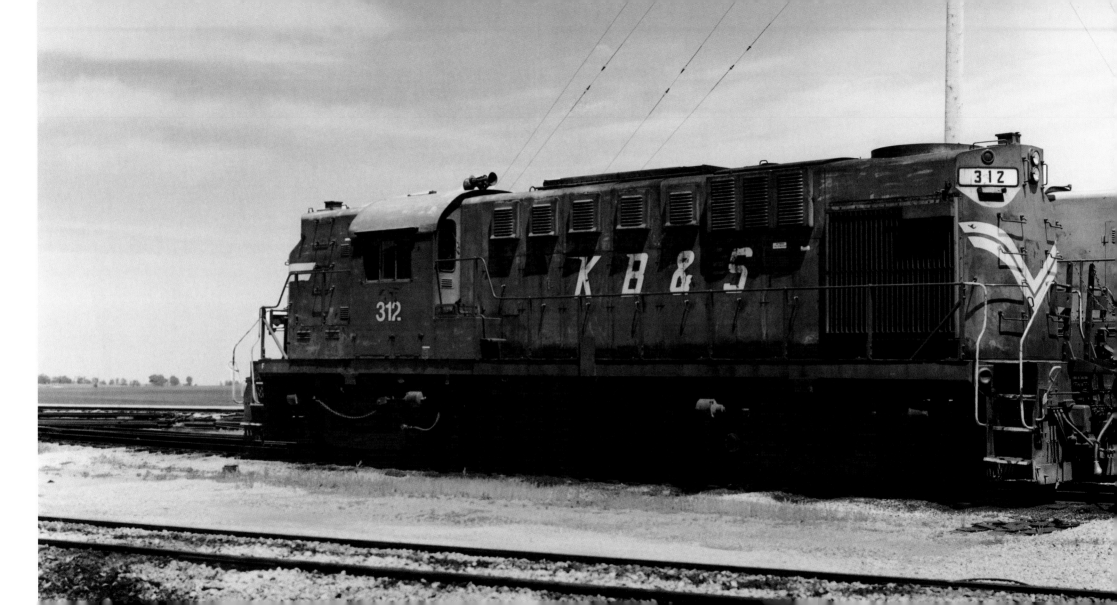

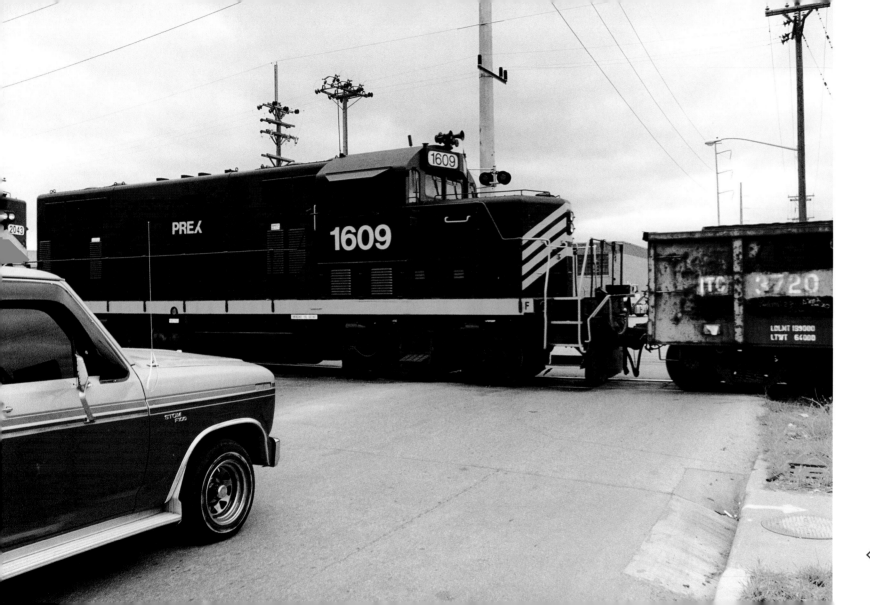

<KANSAS CITY KS 1995

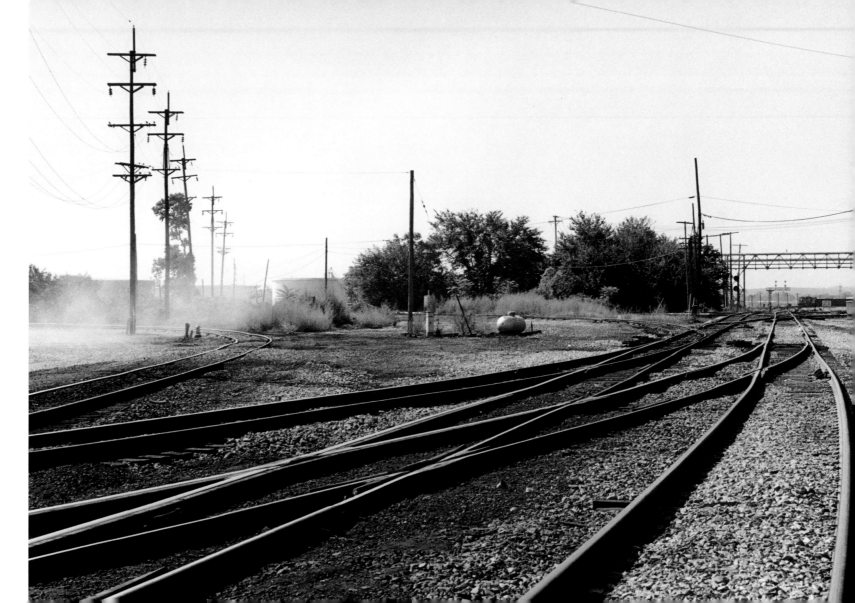

>EAST ST LOUIS IL 1995

0092

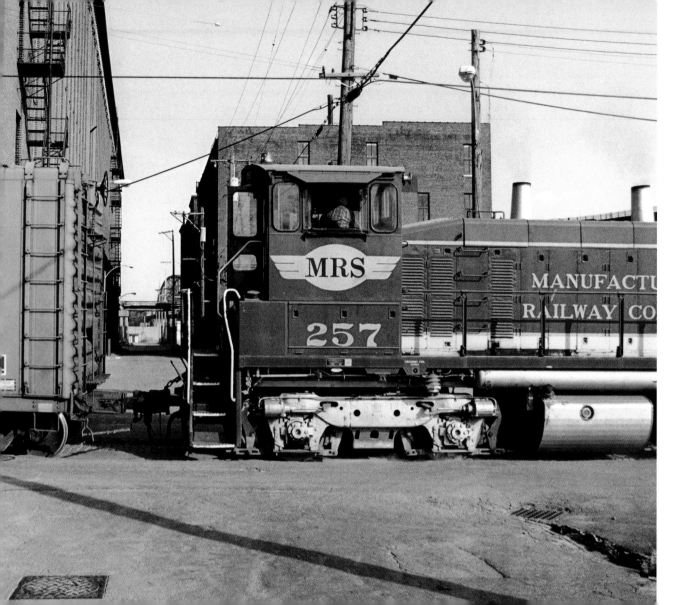

<ST LOUIS MO 1995

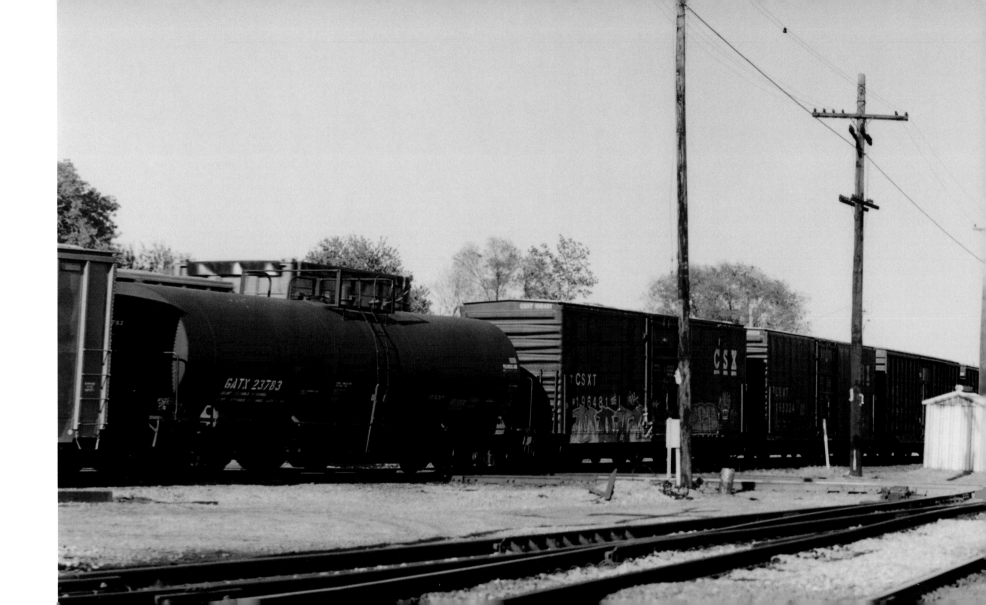

0094

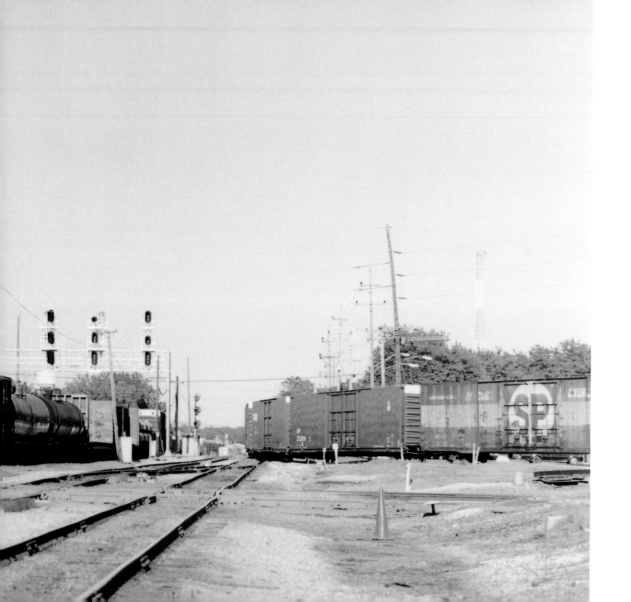

‹DOLTON IL 2001

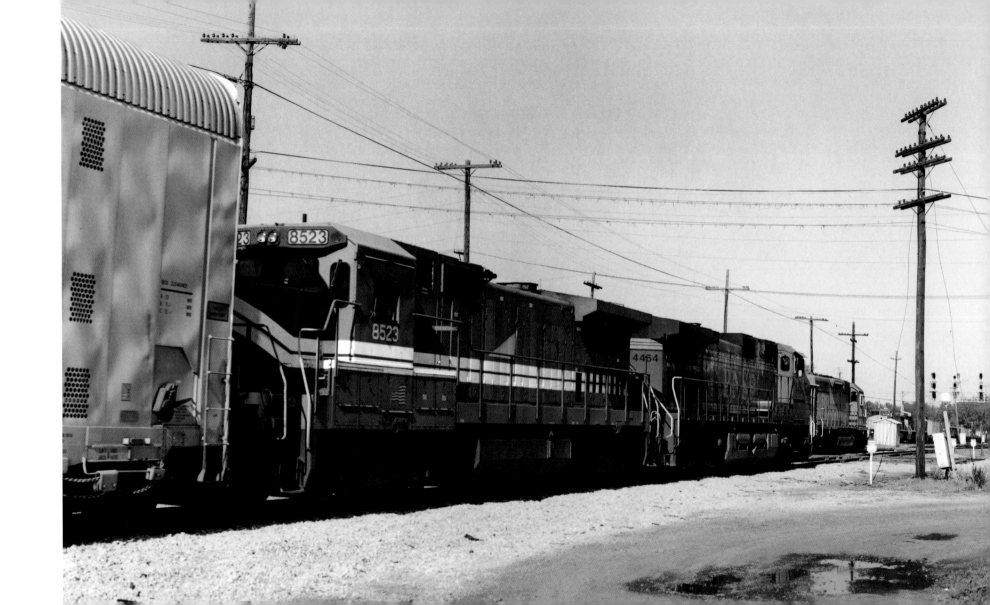

0096

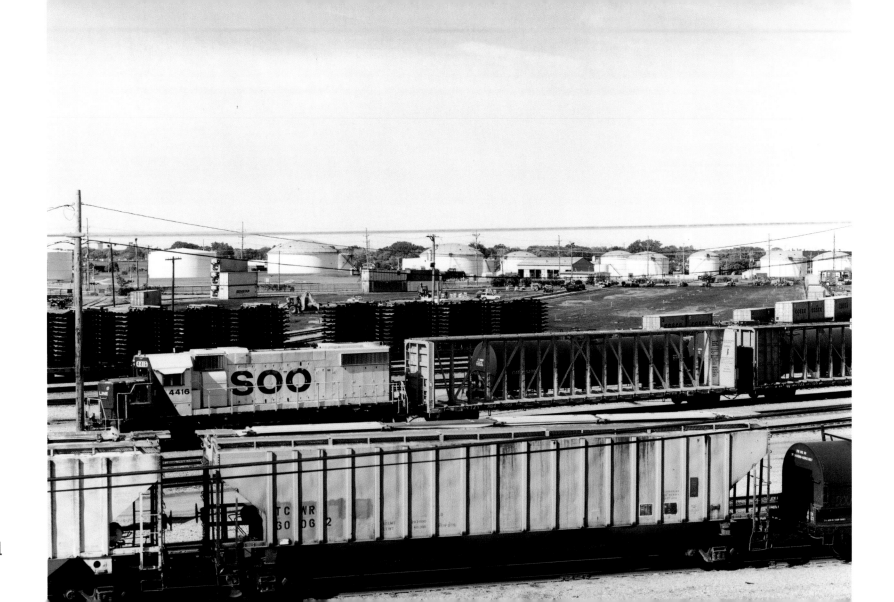

<DOLTON IL 2001
>MANNHEIM IL 2001

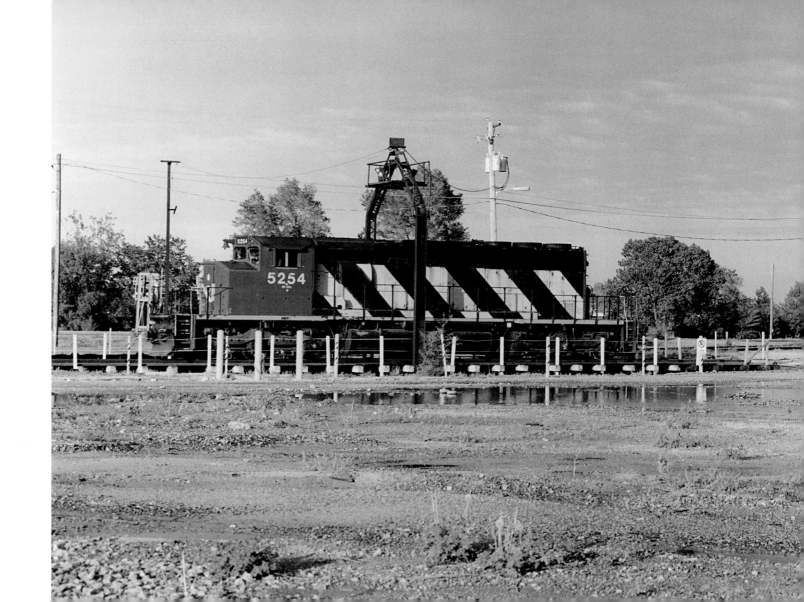

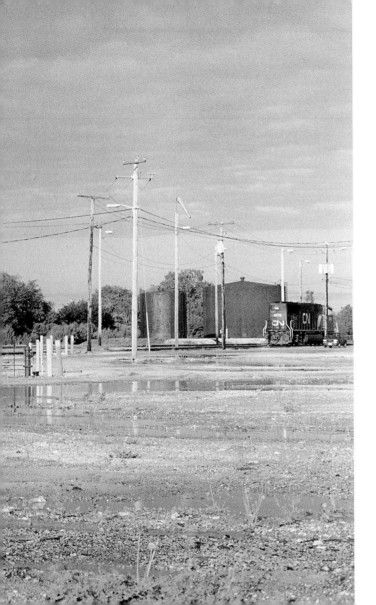

<BENSENVILLE IL 2001

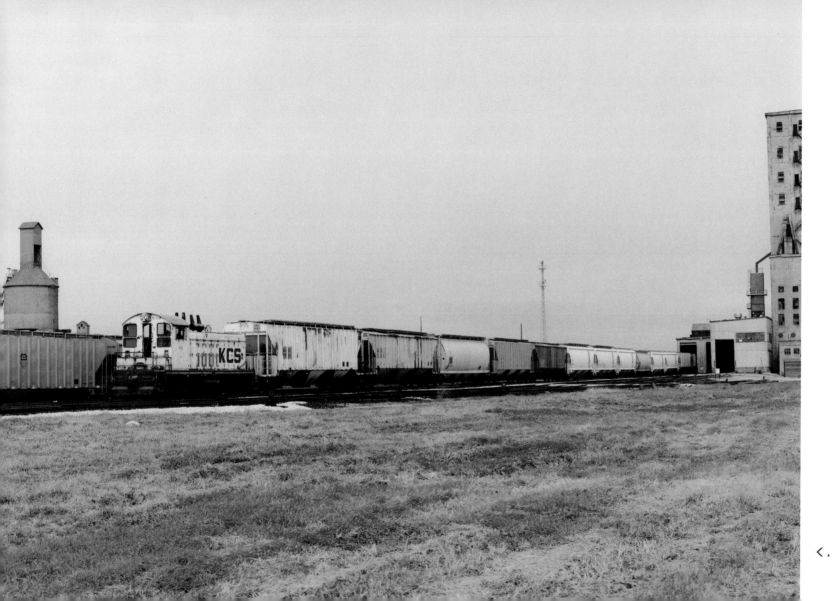

<.> COUNCIL BLUFFS IA 1997

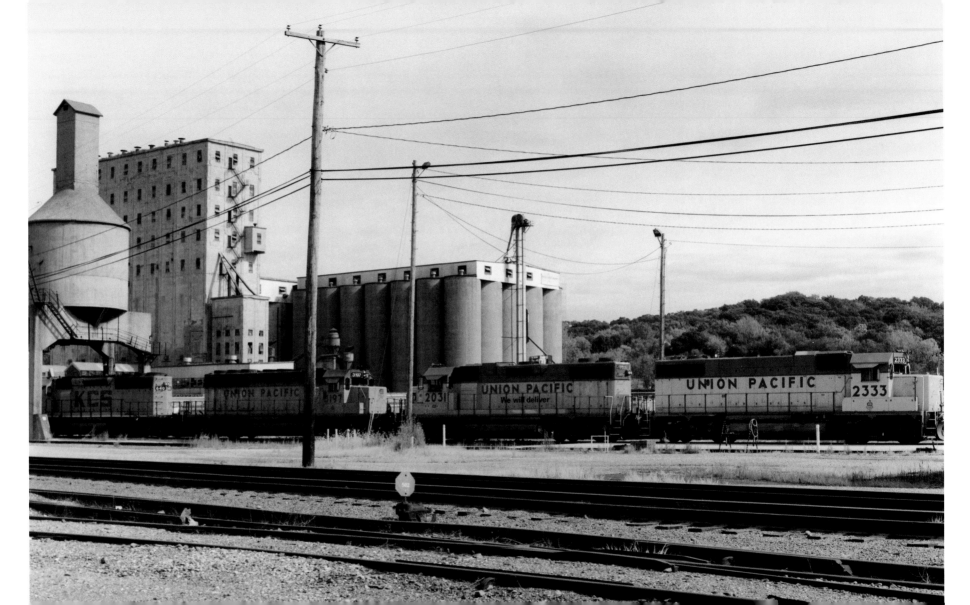

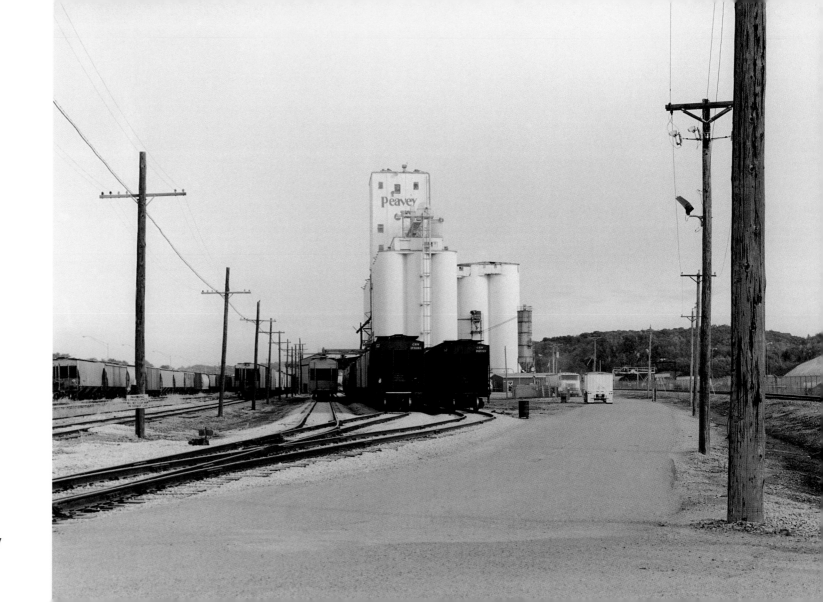

>COUNCIL BLUFFS IA 1997
>>FREMONT NE 1997
>>>WAGNER MILLS NE 1997

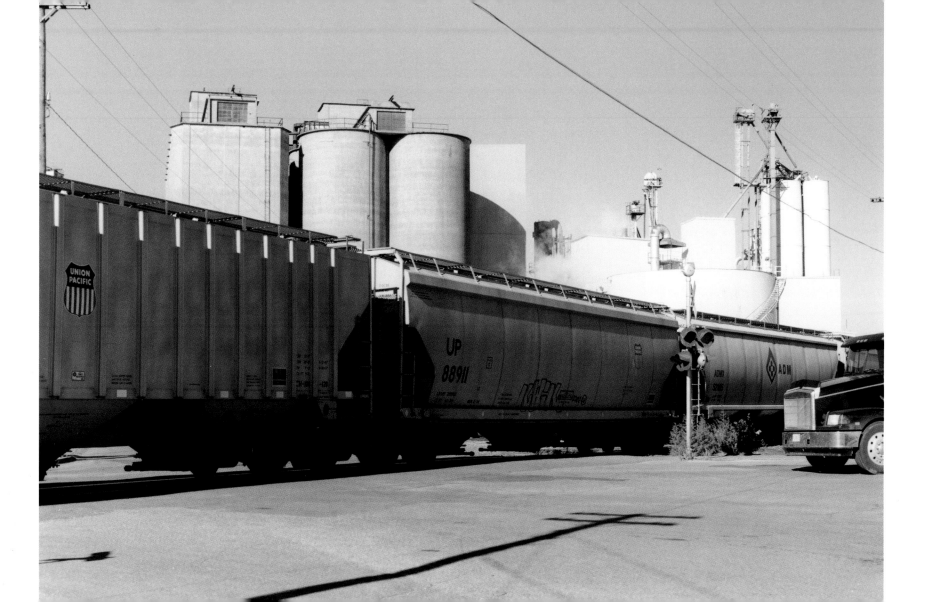

0103

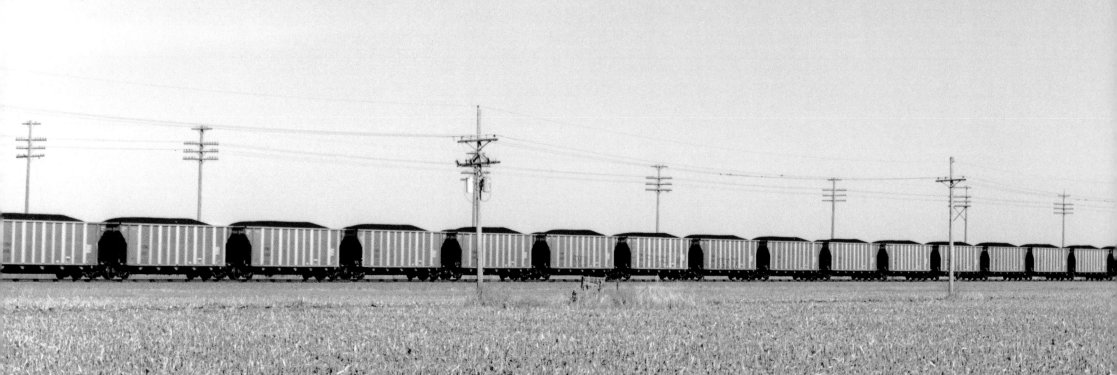

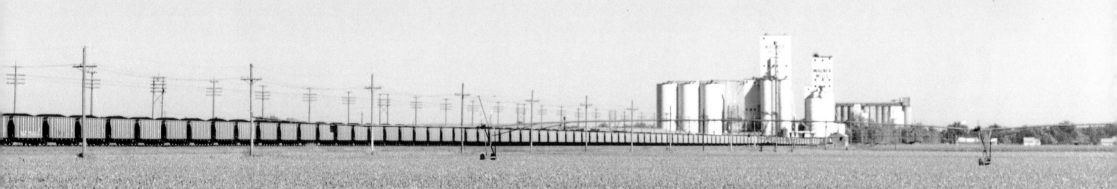

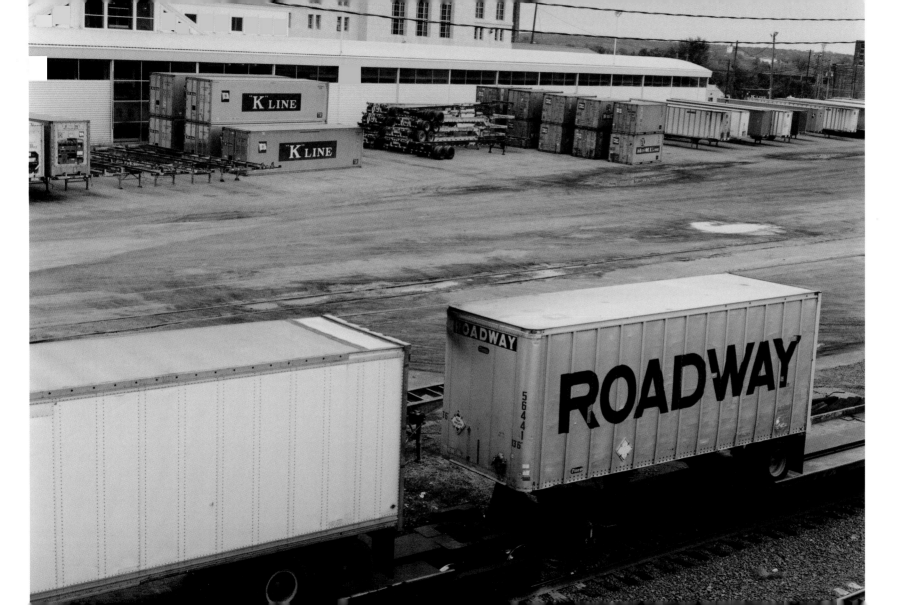

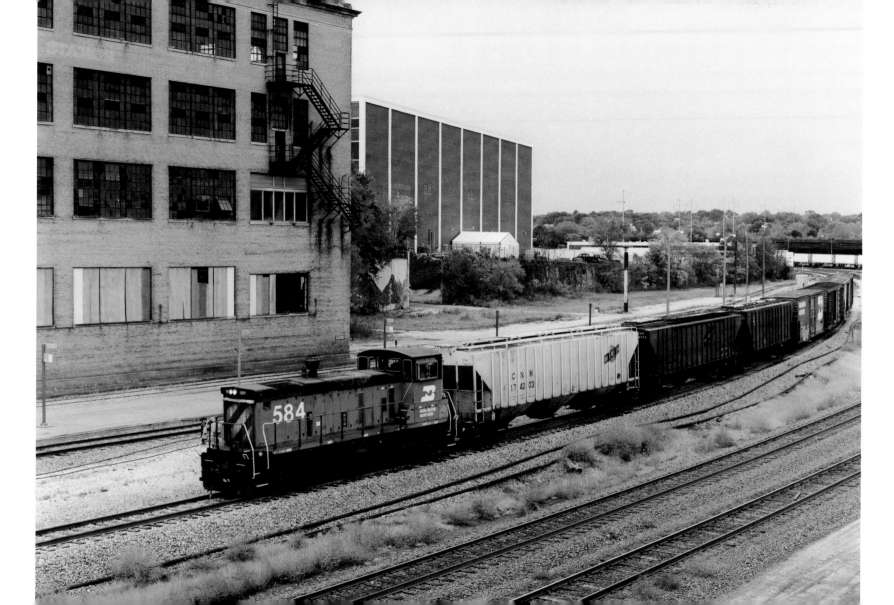

<.>OMAHA NE 1997

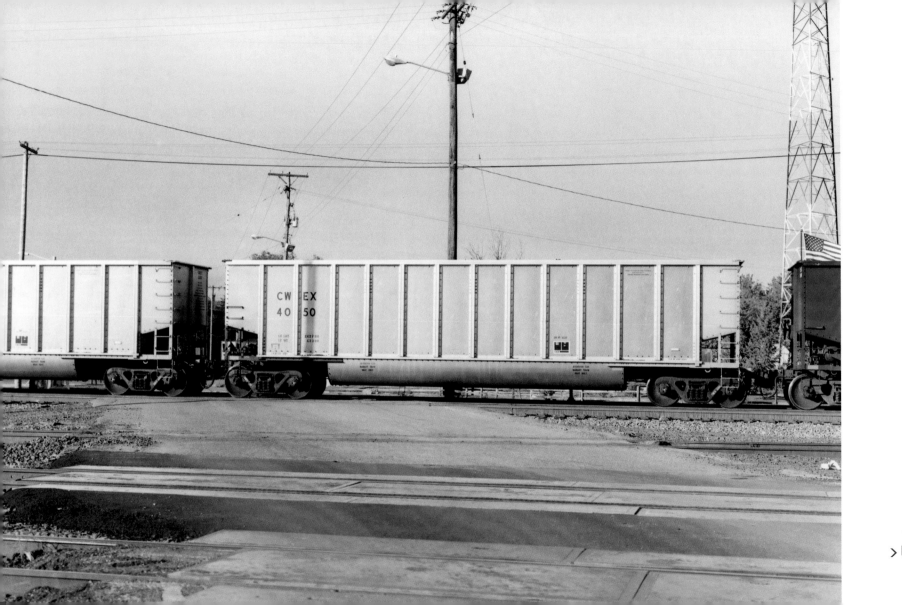

<FREMONT NE 1997
>COLUMBUS NE 1997

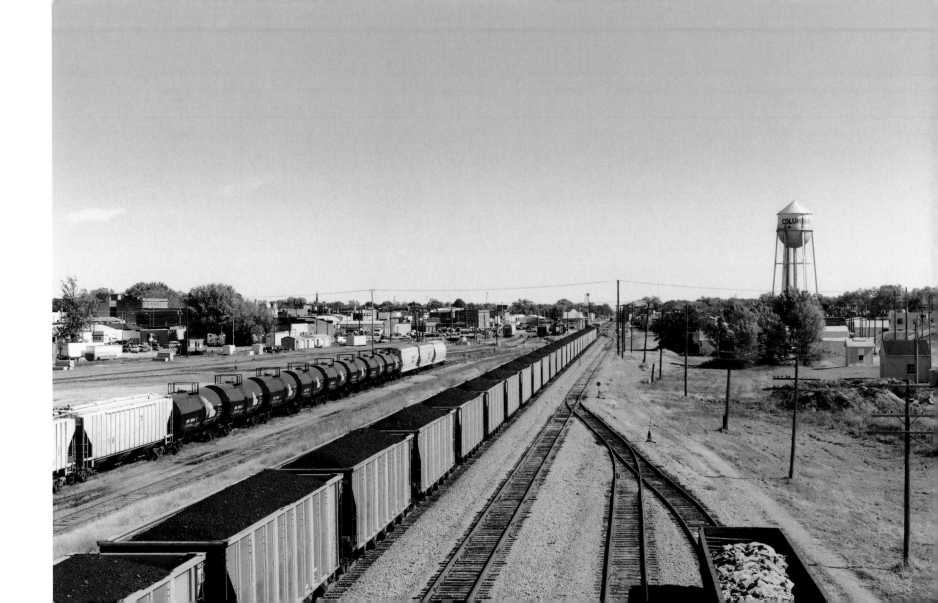

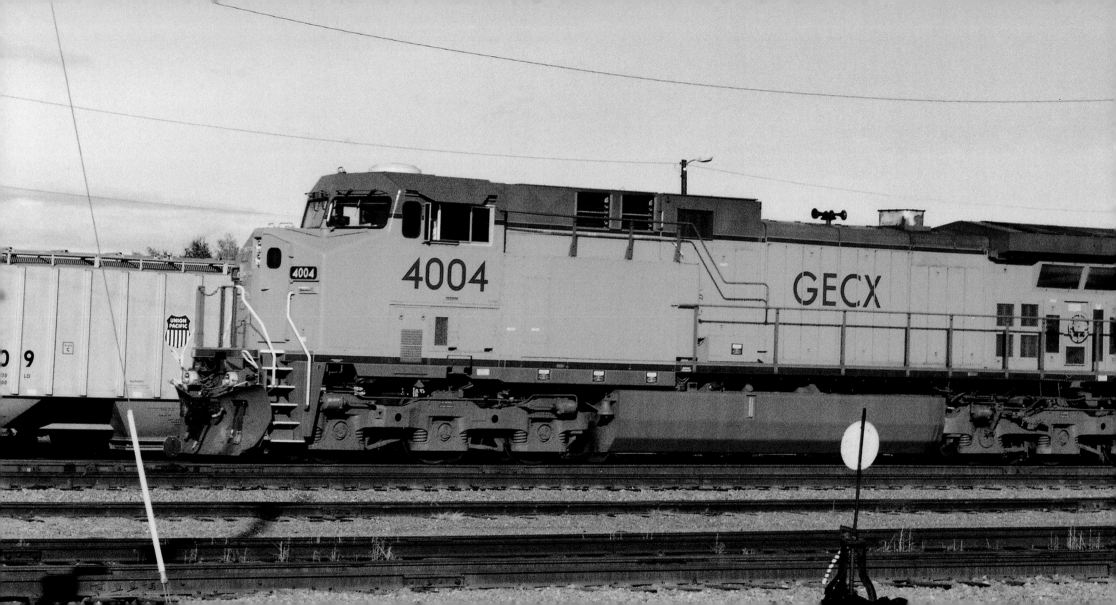

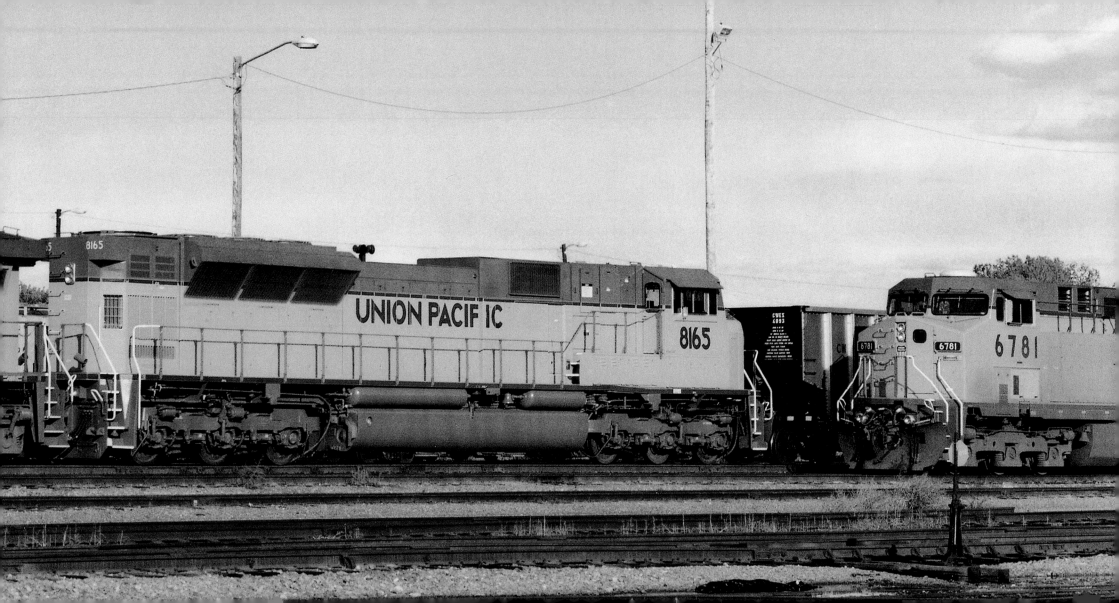

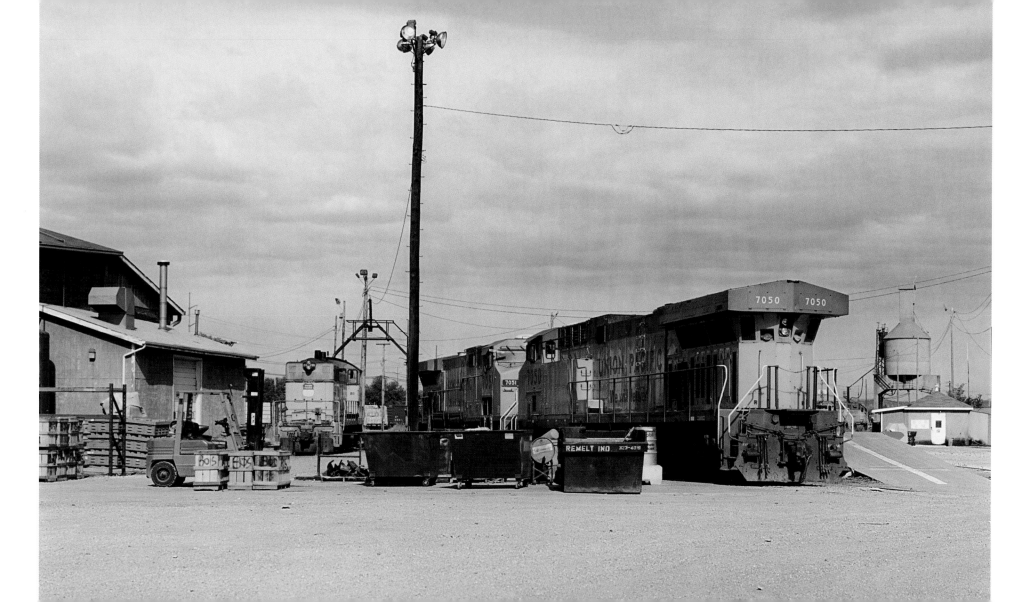

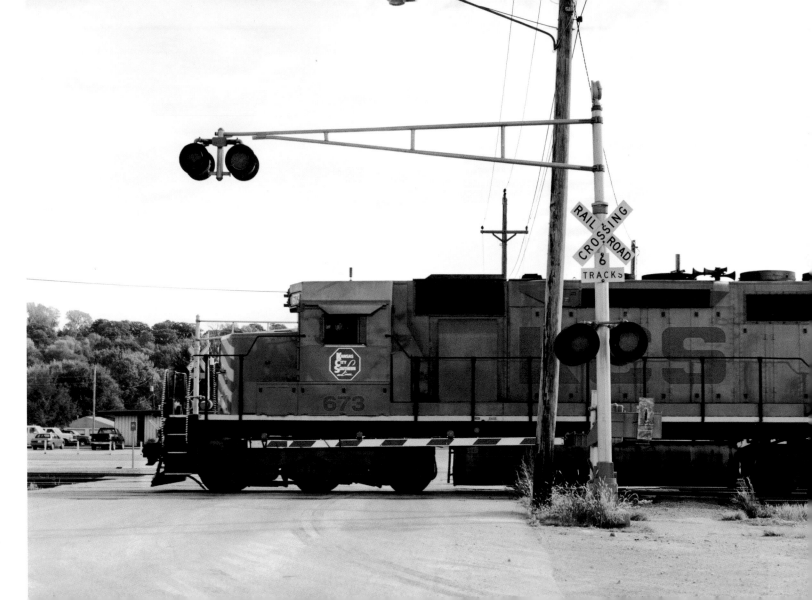

SOME TRAINS IN AMERICA: NORTHWEST

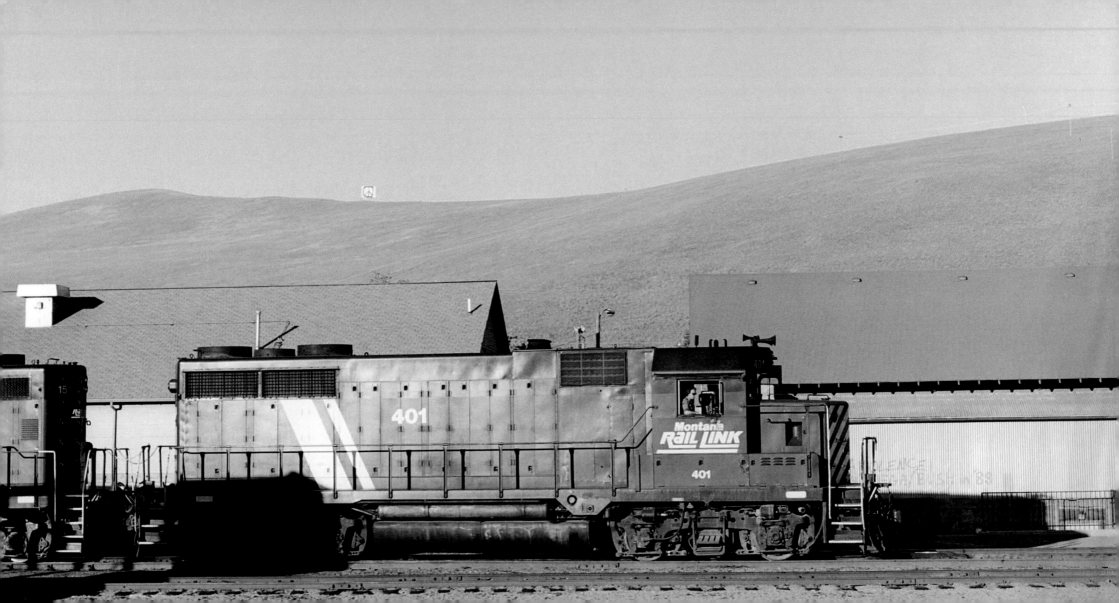

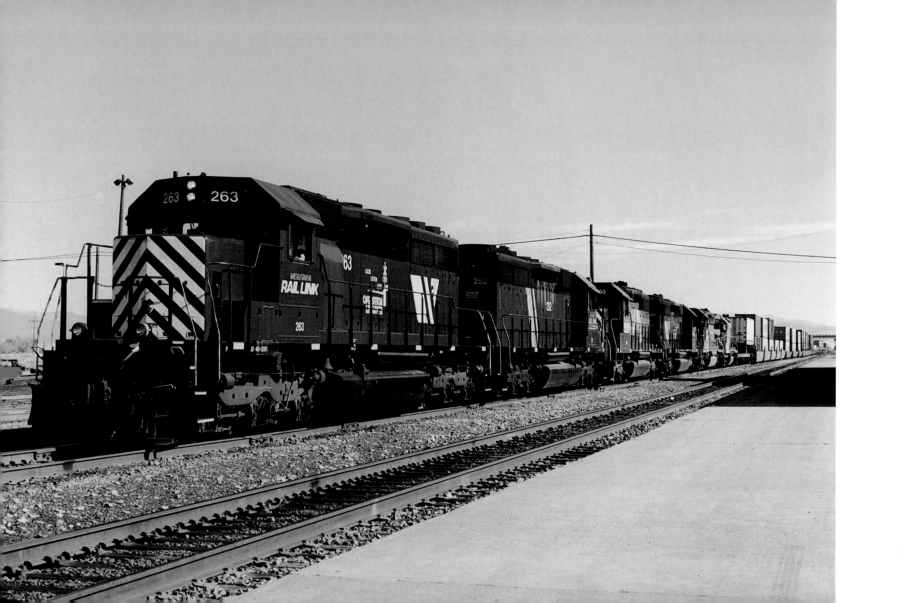

<.>HELENA MT 1997

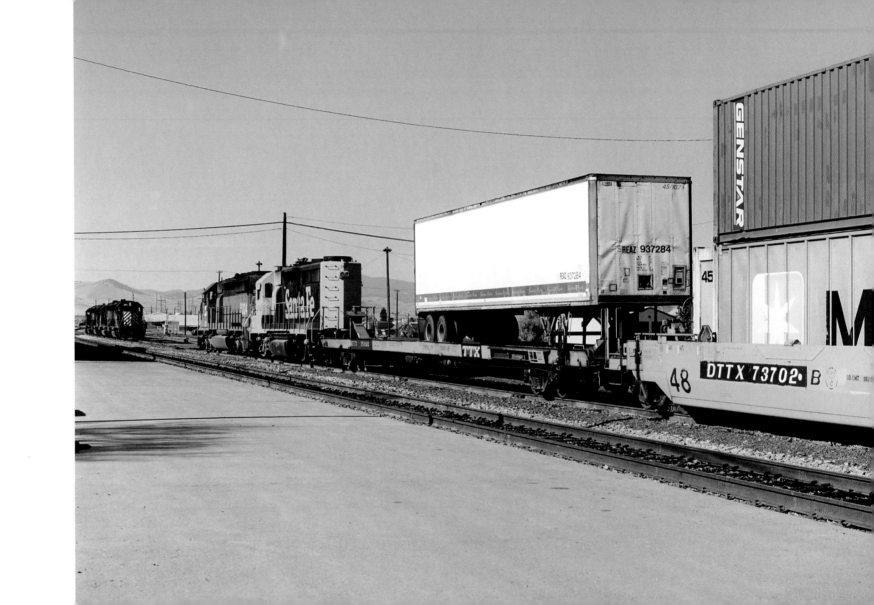

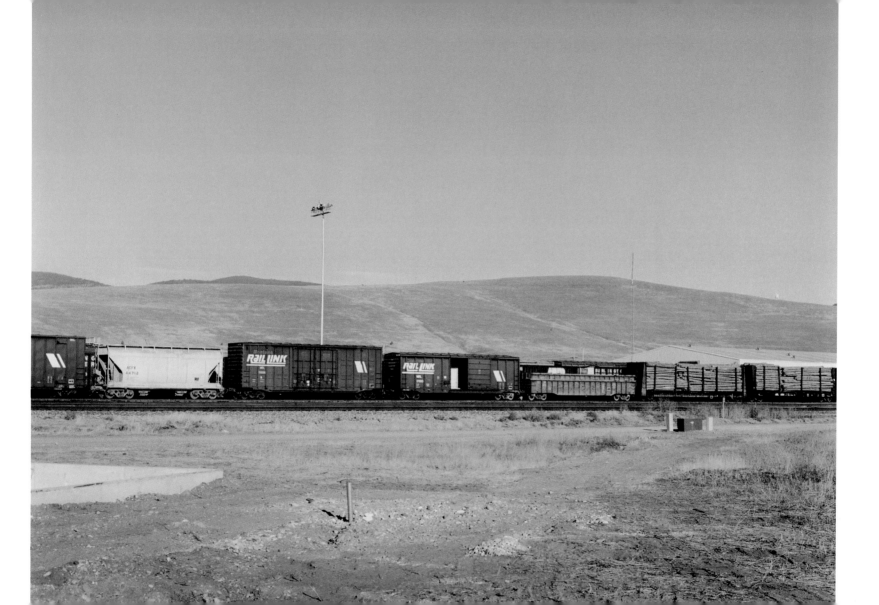

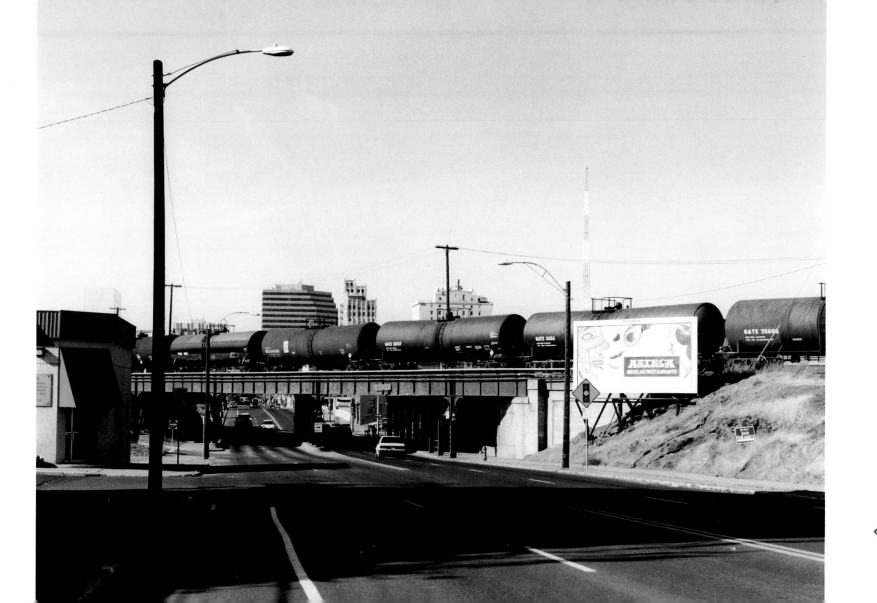

<<MISSOULA MT 1997
<SPOKANE WA 1997

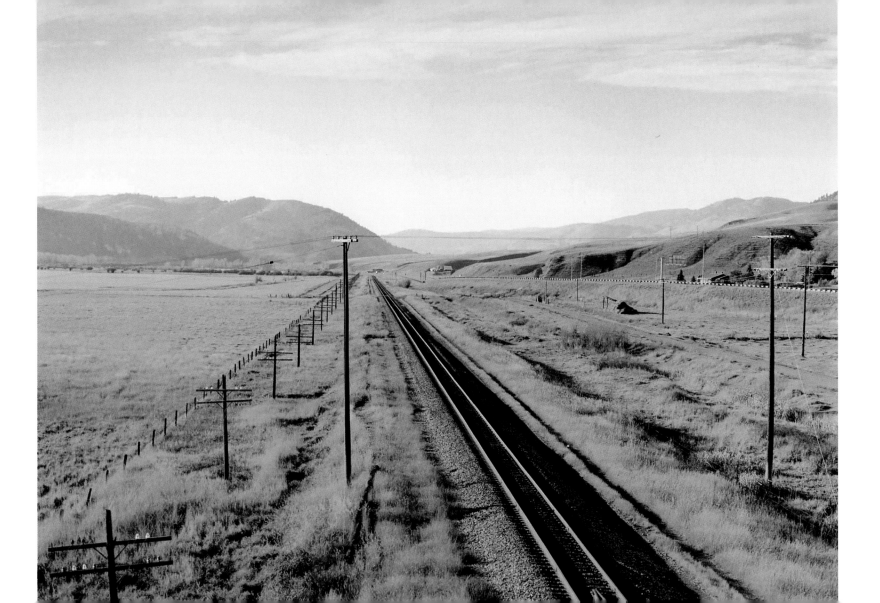

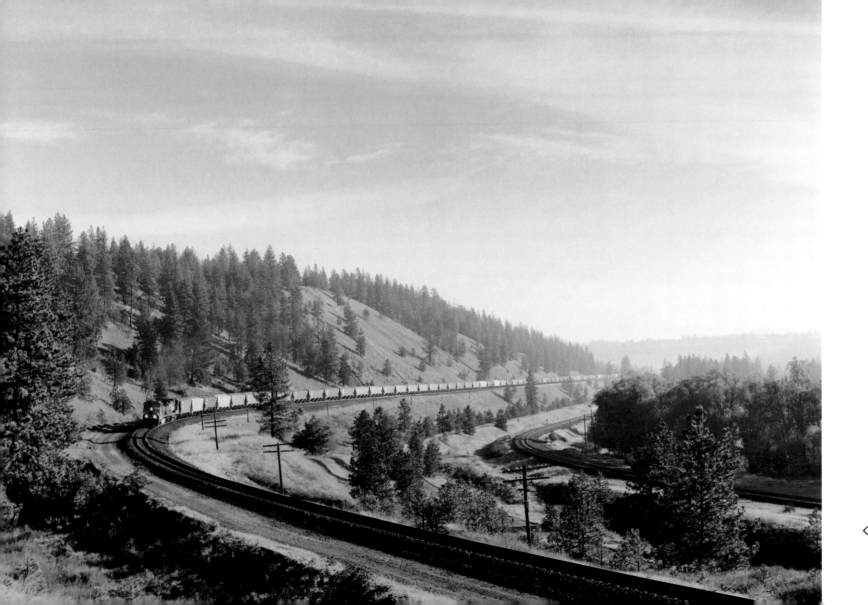

<<DRUMMOND MT 1997
<MARSHALL WA 1997

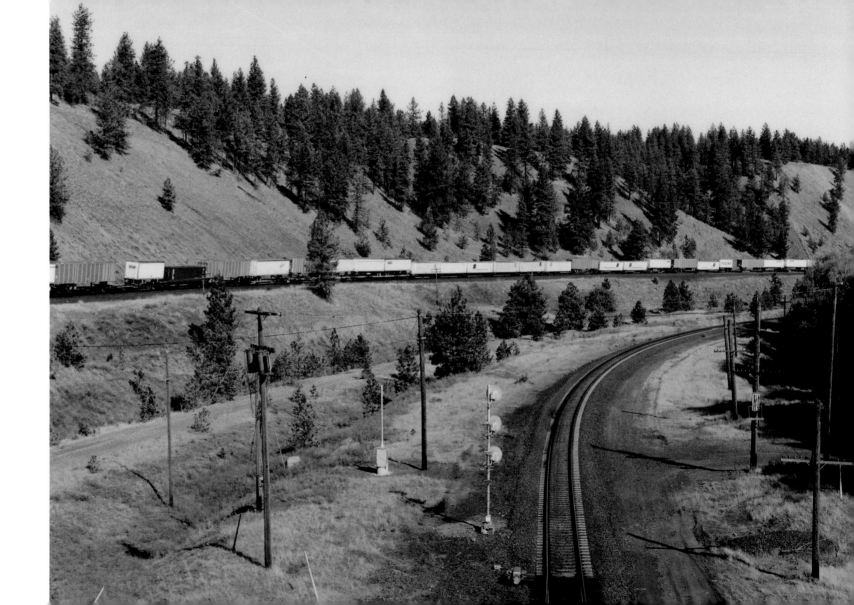

> MARSHALL WA 1997
>> WENATCHEE WA 1999

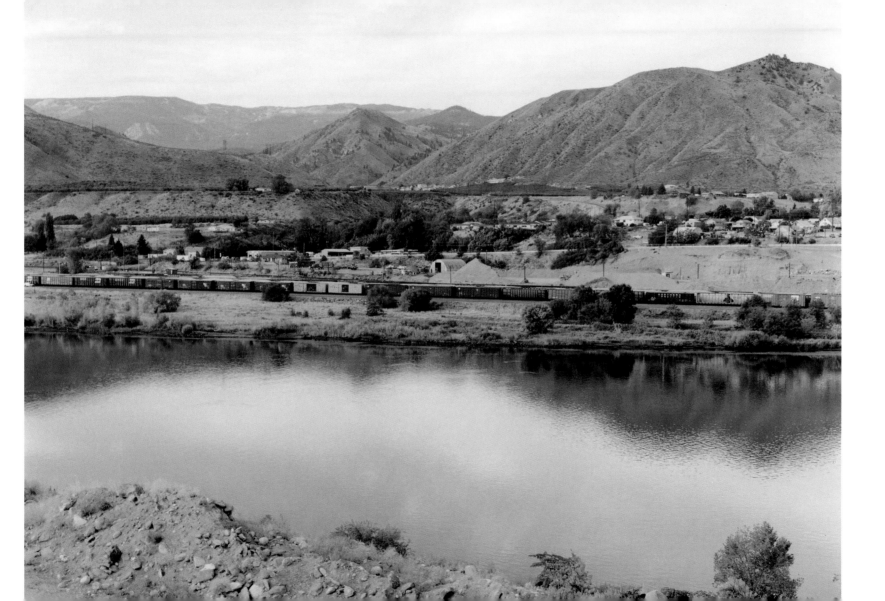

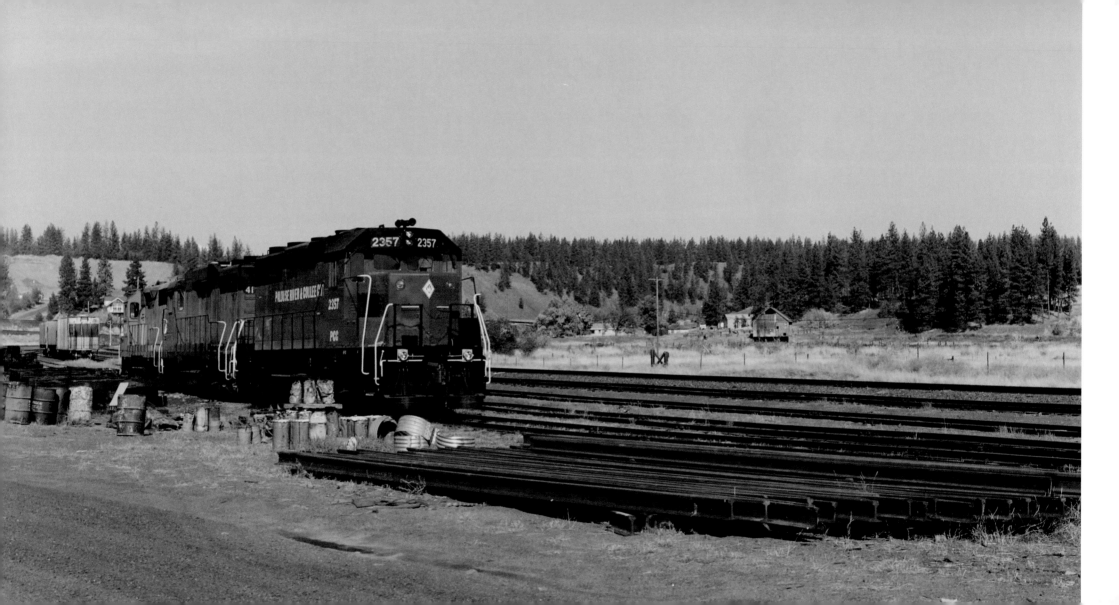

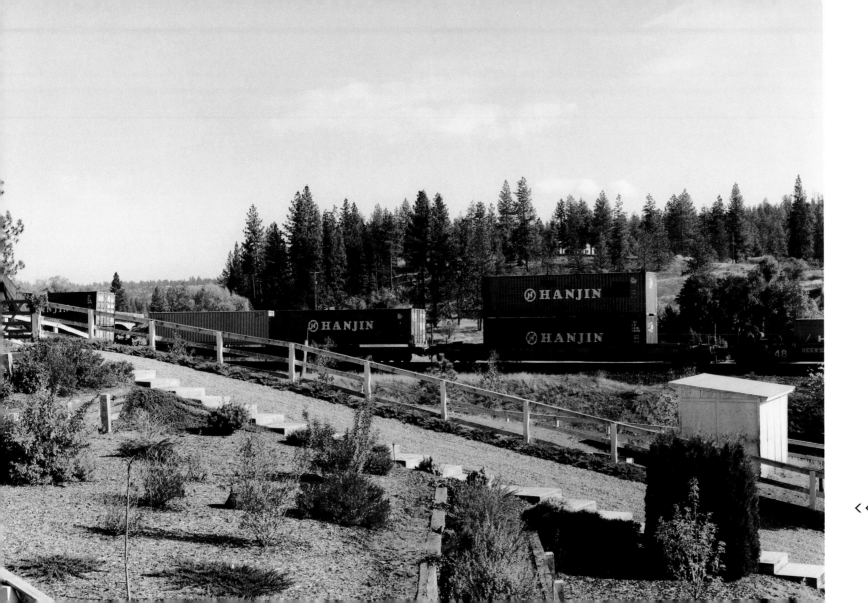

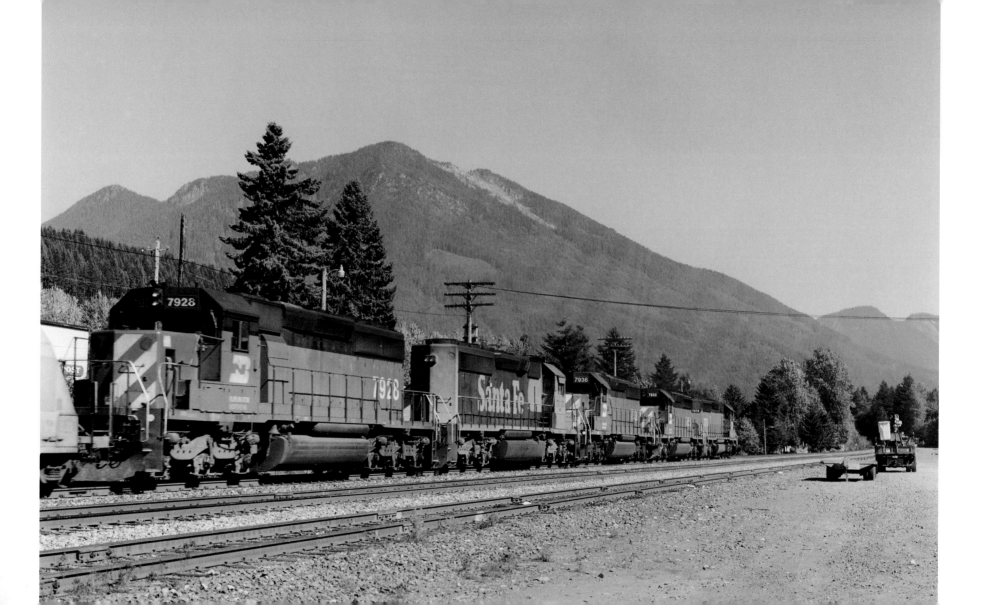

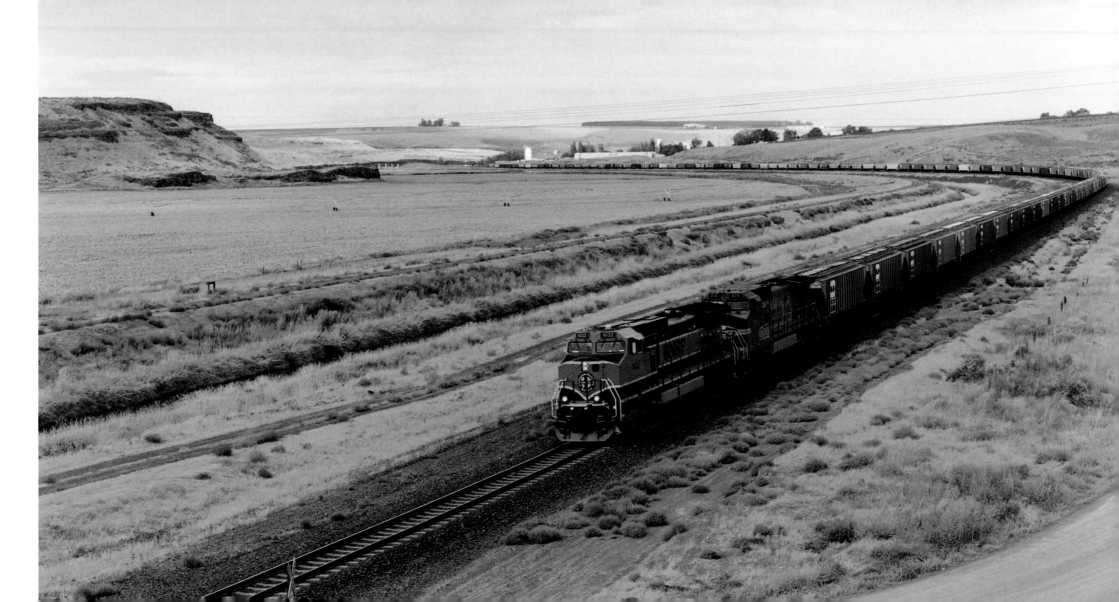

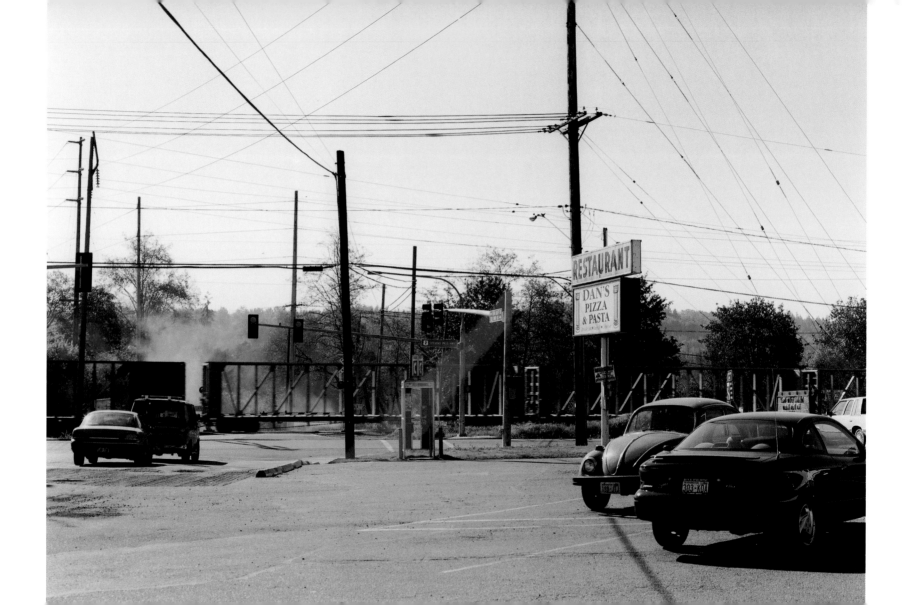

0128

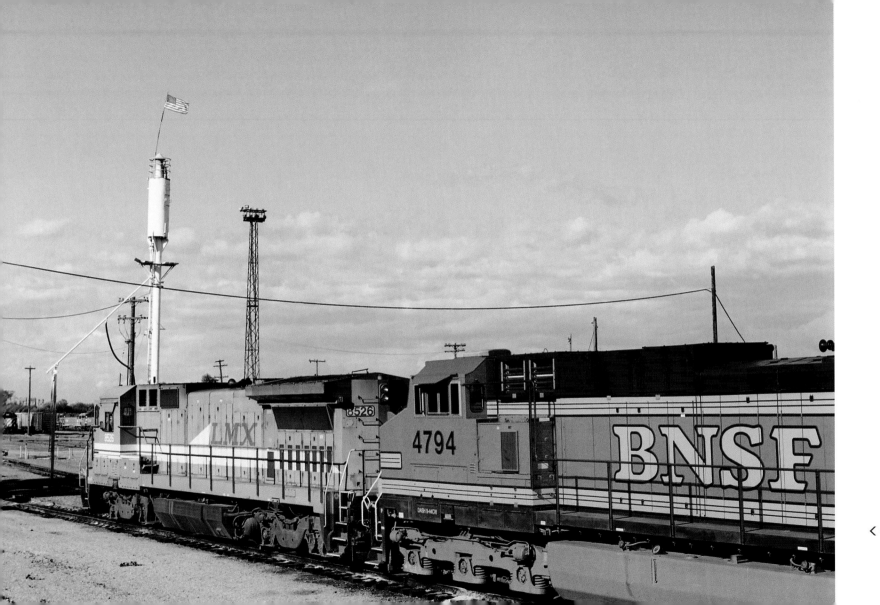

<<GOLD BAR WA 1999
<EVERETT WA 1999

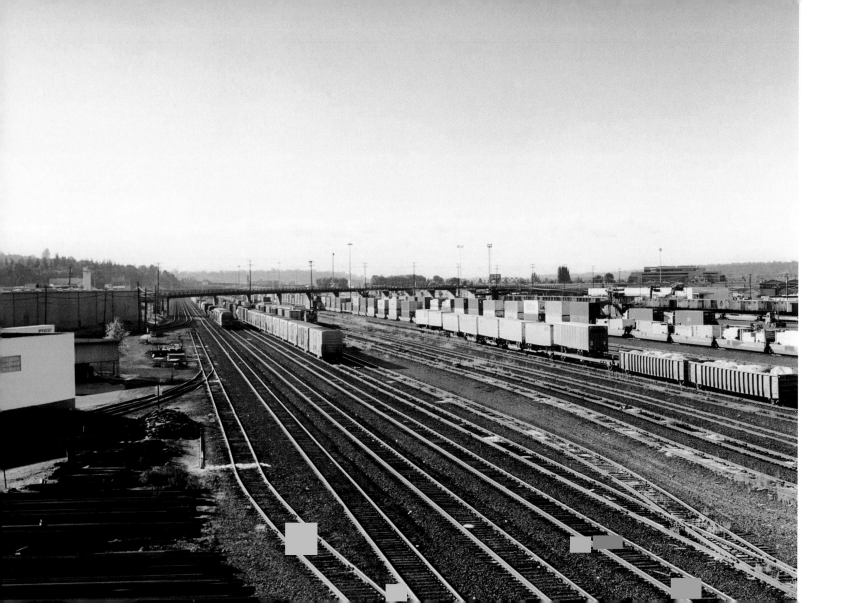

<.>SEATTLE WA 1999

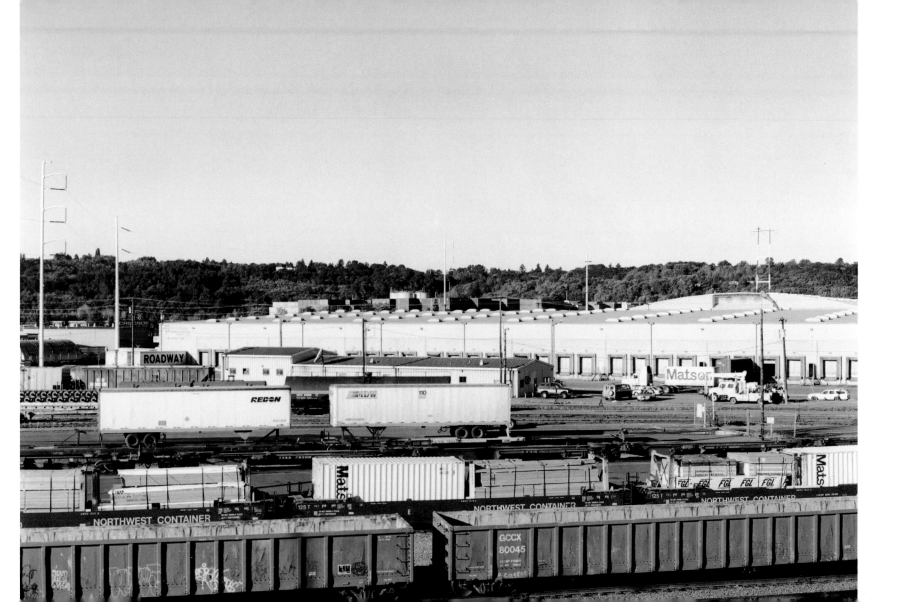

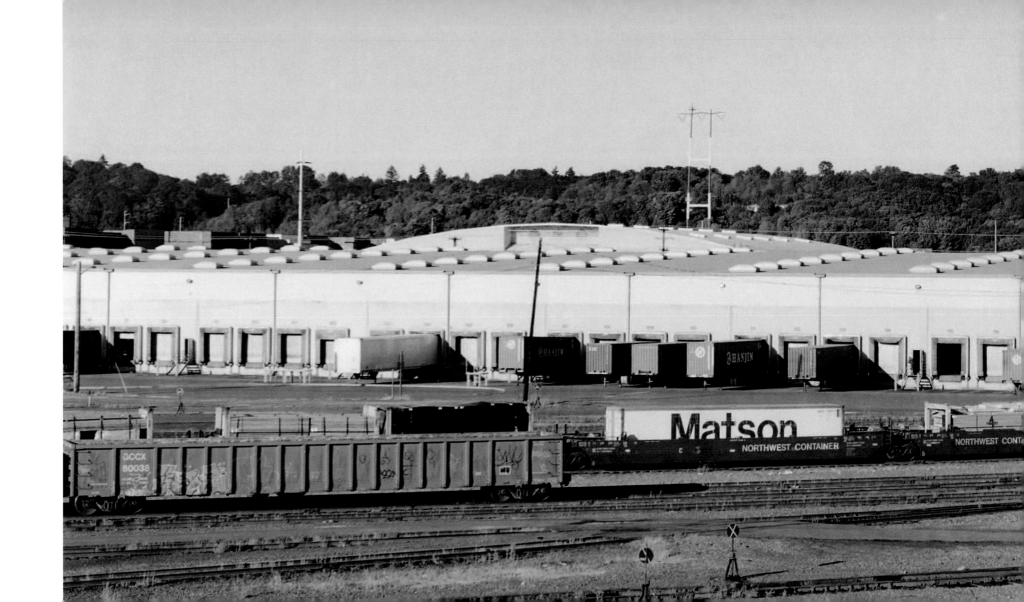

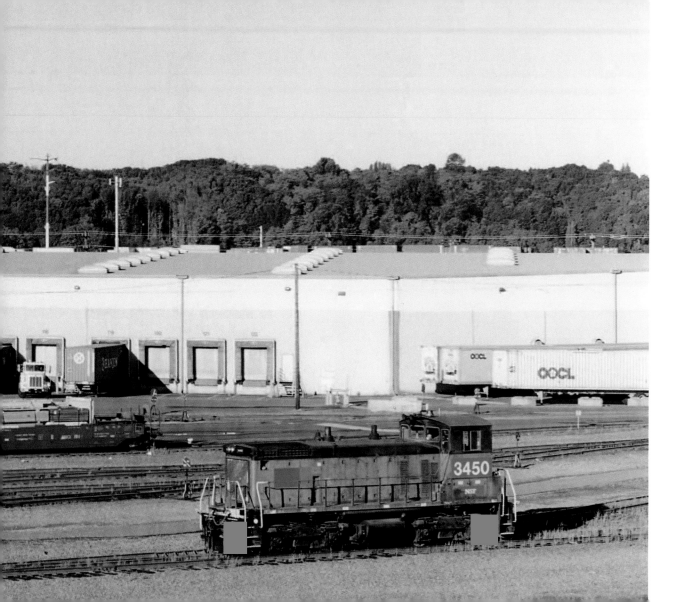

<.>SEATTLE WA 1999

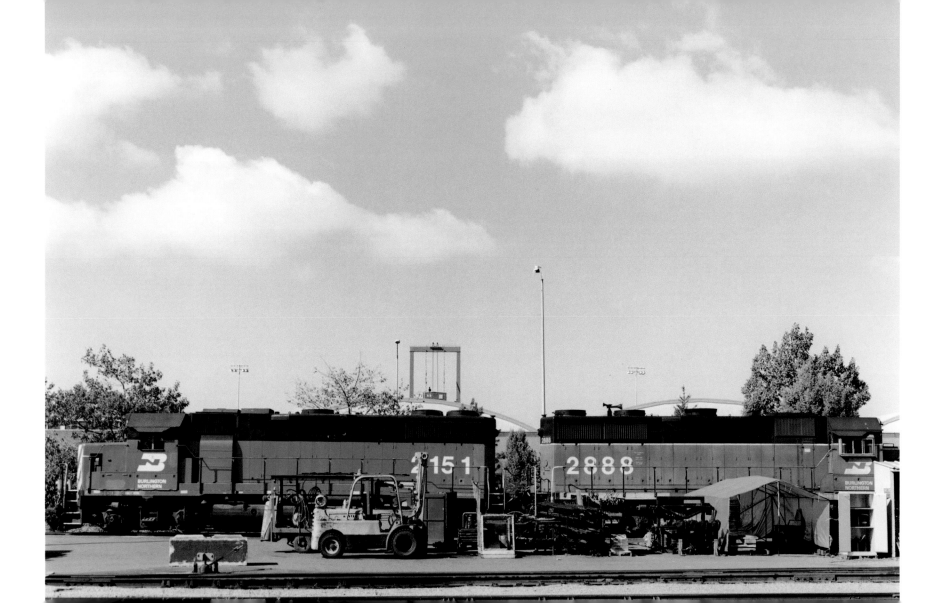

0134

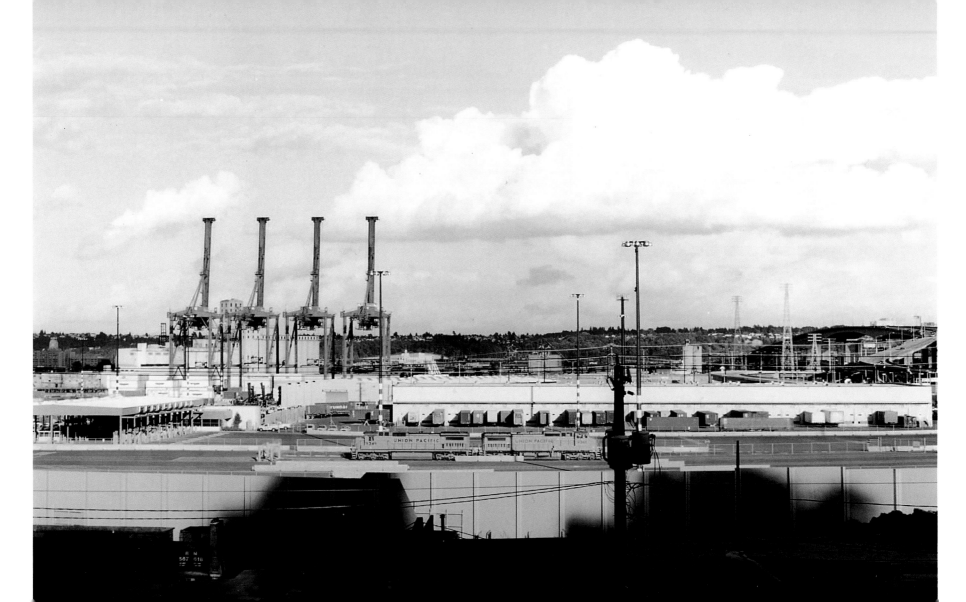

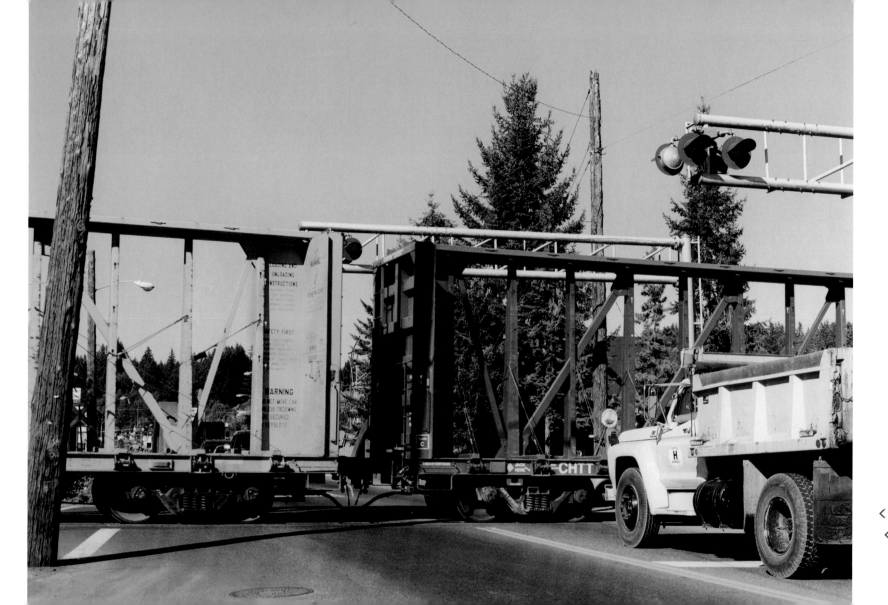

<<SEATTLE WA 1999
<SHELTON WA 1999
>TACOMA WA 1999

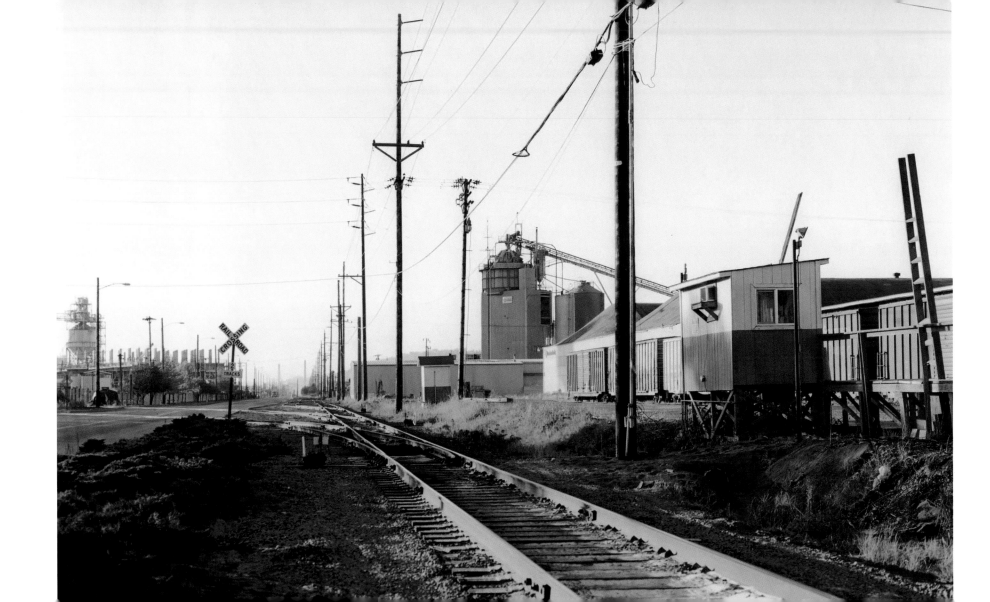

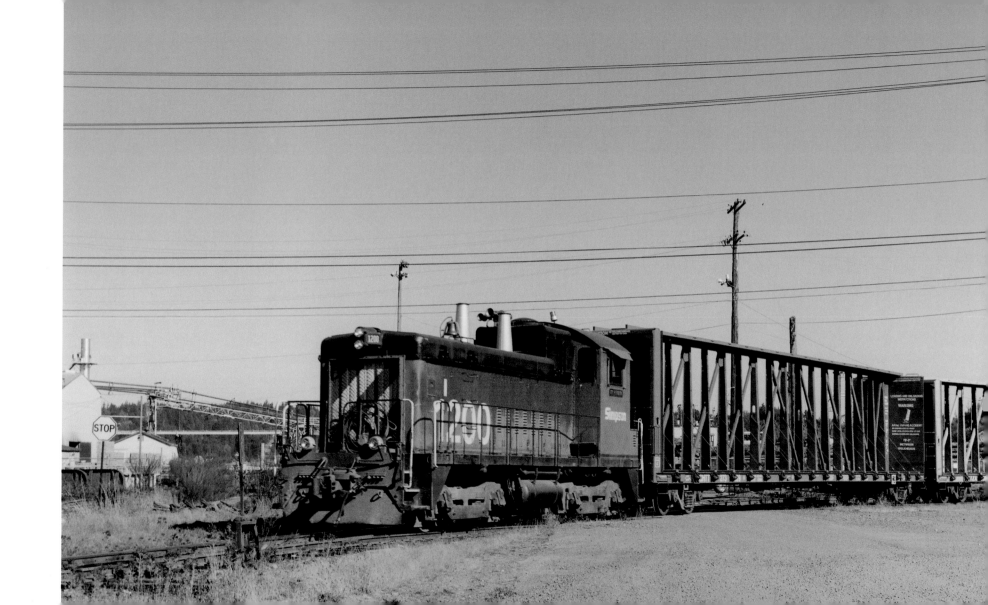

0138

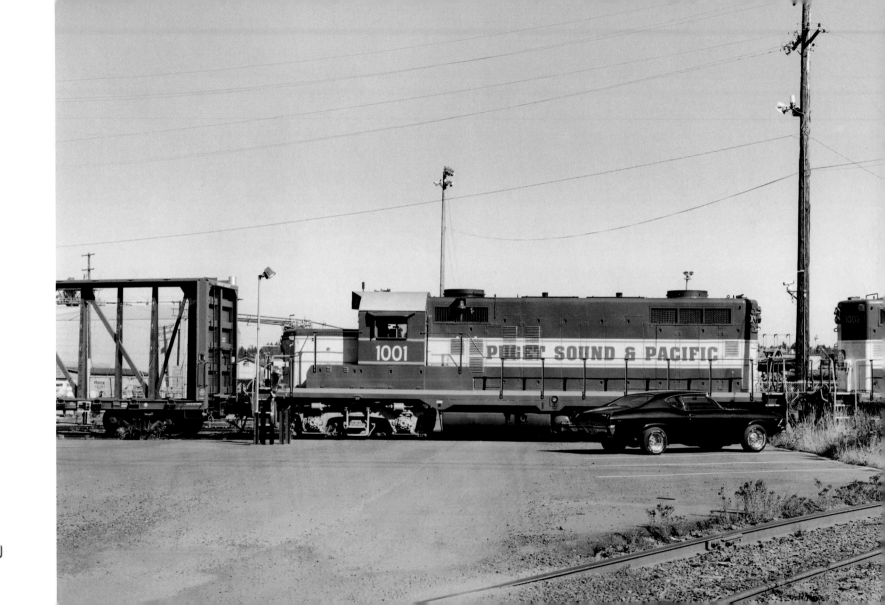

<.>SHELTON WA 1999

SOME TRAINS IN AMERICA: CENTRAL CALIFORNIA

>MODESTO CA 1997

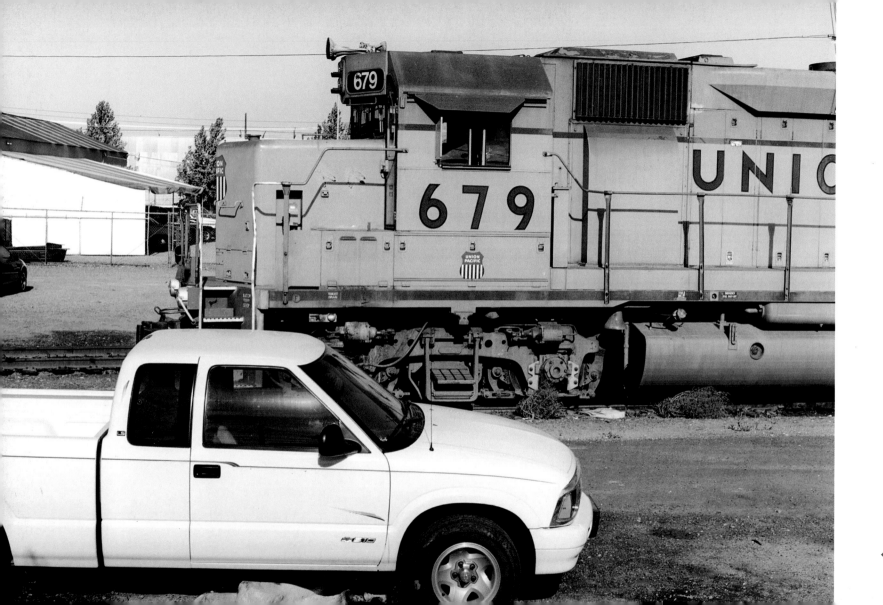

<.> MODESTO CA 1997

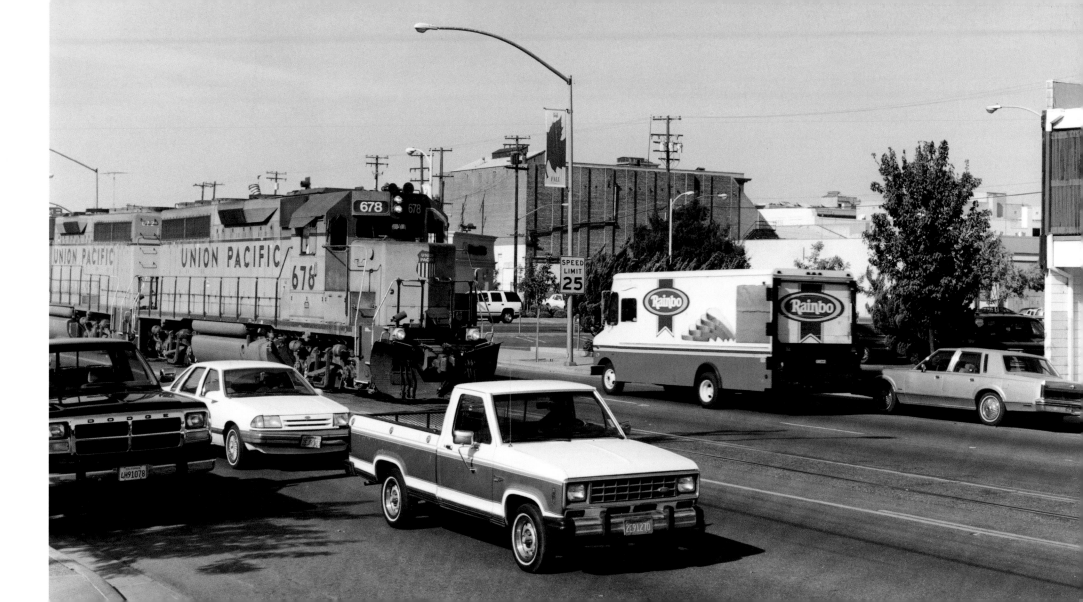

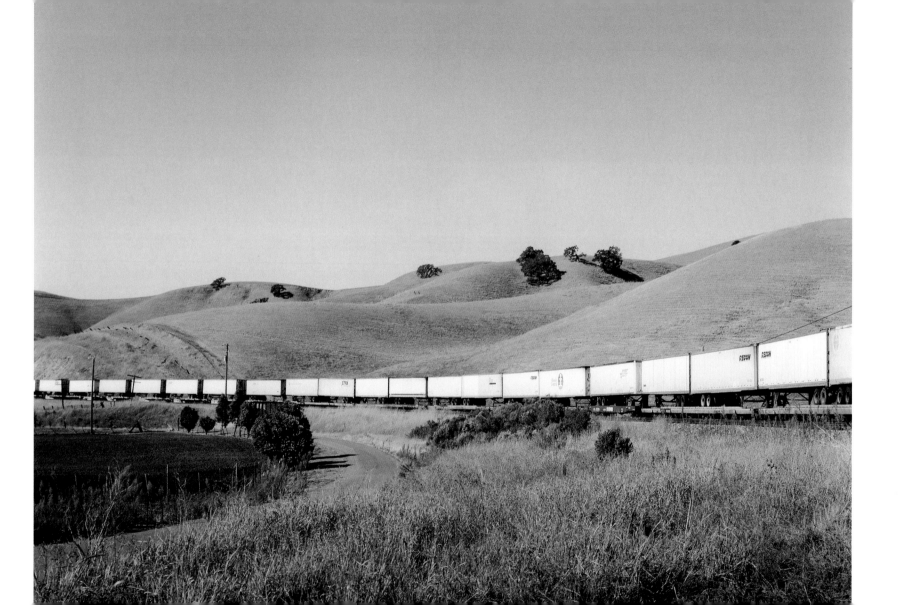

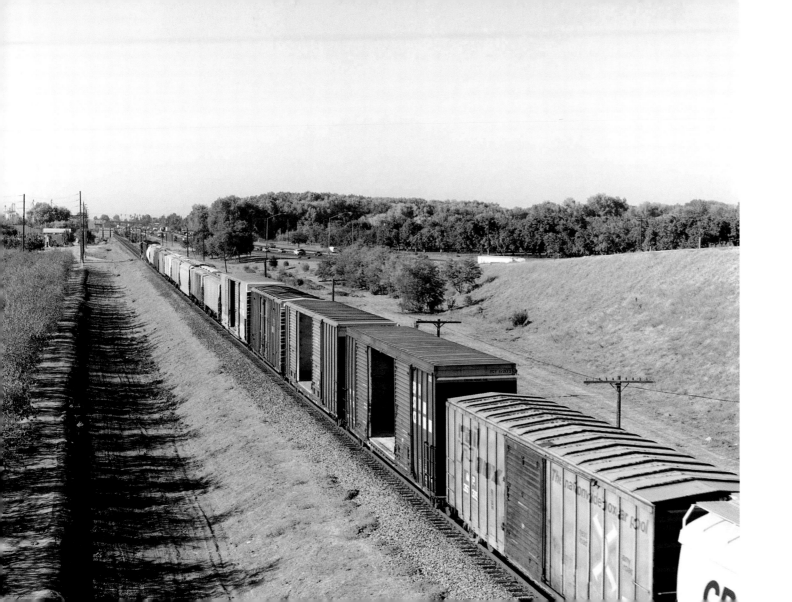

<<CHRISTIE CA 1997
<COVELL CA 1997

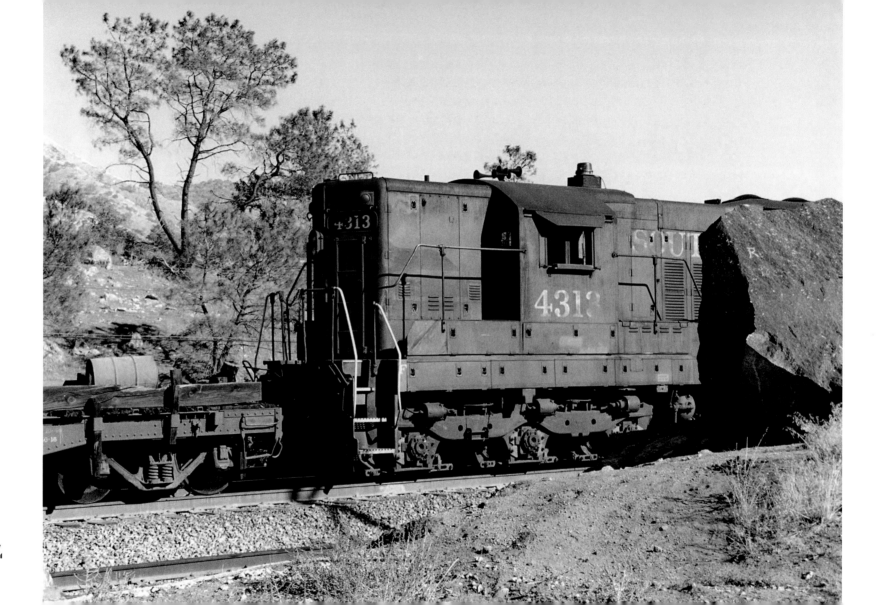

>WOODFORD CA 1994

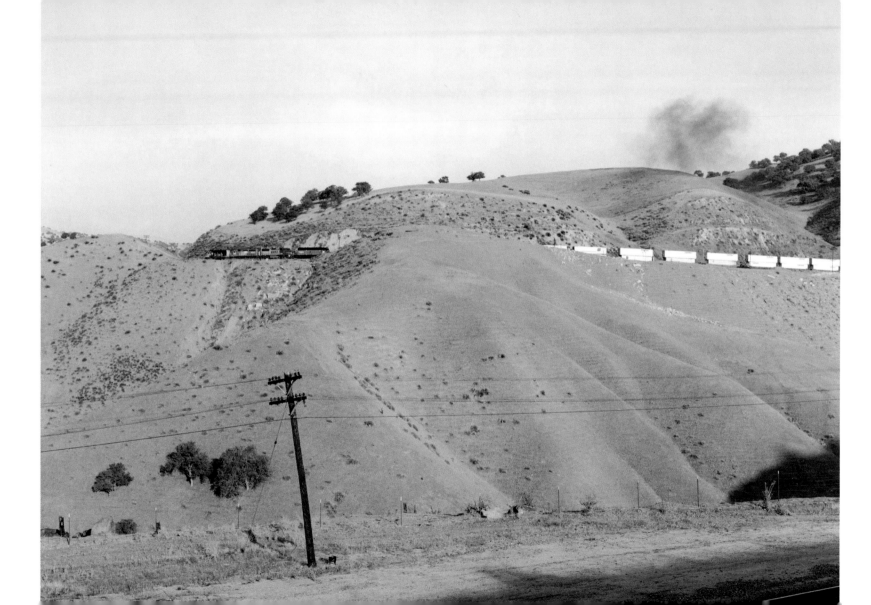

>BEALVILLE CA 1997

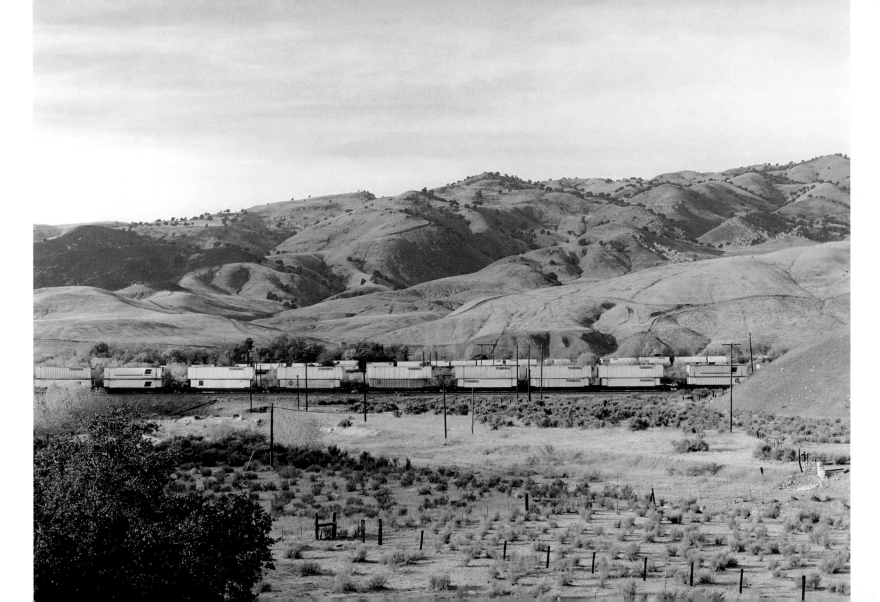

>CALIENTE CA 1997

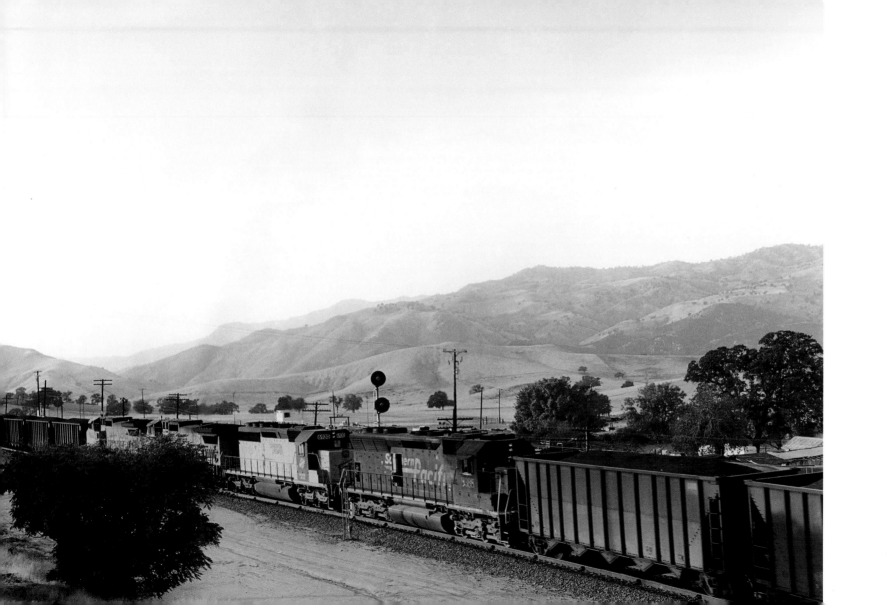

‹BEALVILLE CA 1997

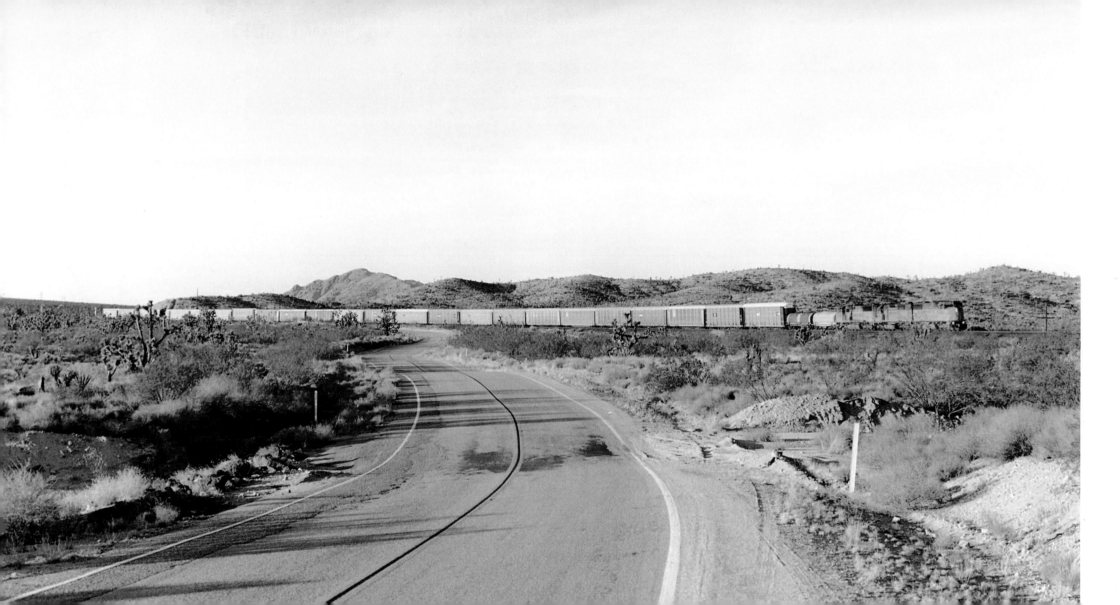

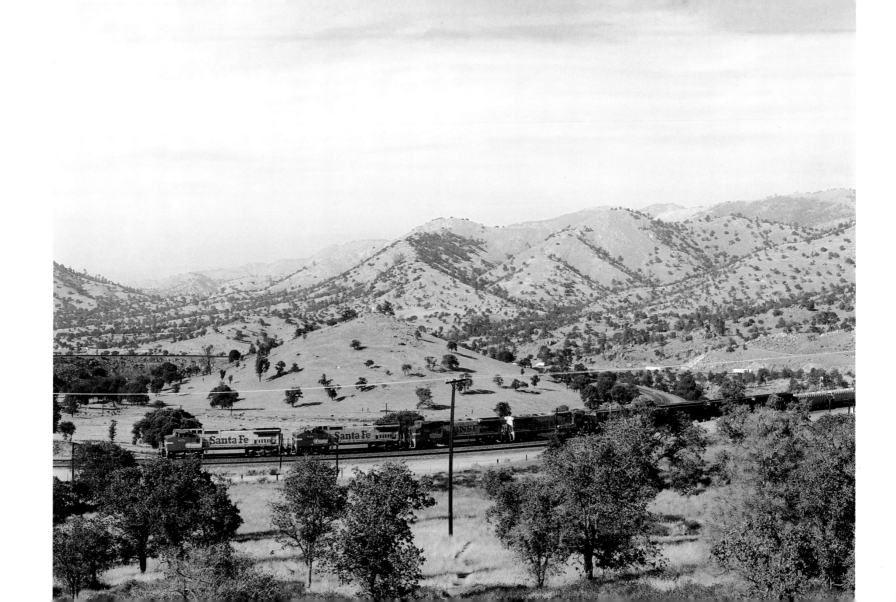

<CIMA RD CA 2000
>WALONG CA 1997

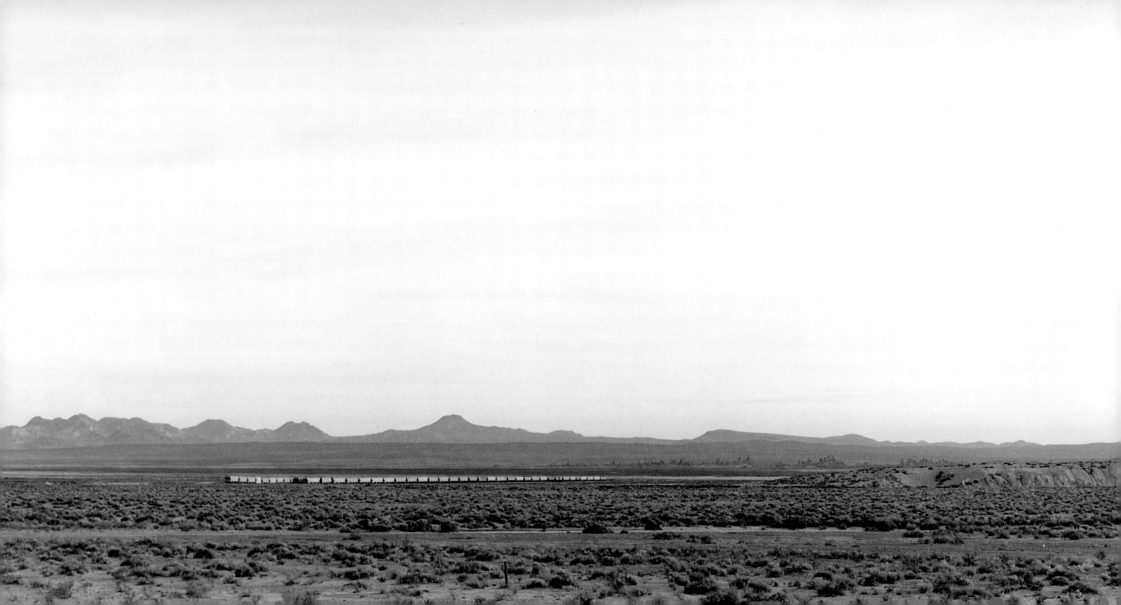

<PINNACLE CA 2000

1823	THE FIRST RAILROAD IN NORTH AMERICA – THE BALTIMORE & OHIO – IS CHARTERED BY BALTIMORE MERCHANTS
1830	THE FIRST REGULARLY SCHEDULED STEAM-POWERED RAIL PASSENGER SERVICE IN THE U.S. BEGINS OPERATION IN SOUTH CAROLINA, UTILIZING THE U.S.-BUILT LOCOMOTIVE <THE BEST FRIEND OF CHARLESTON>
1833	A TOTAL OF 380 MILES OF RAIL TRACK ARE IN OPERATION IN THE U.S.A.
1850	MORE THAN 9,000 MILES OF TRACK ARE IN OPERATION, AS MUCH AS THE REST OF THE WORLD COMBINED
1860	MORE THAN 30,000 MILES OF TRACK ARE IN OPERATION
1862	PRESIDENT LINCOLN SIGNS THE PACIFIC RAILROAD ACT FOR THE CONSTRUCTION OF THE TRANSCONTINENTAL RAILROAD THAT WILL ULTIMATELY LINK CALIFORNIA WITH THE REST OF THE NATION
1865	THE <GOLDEN AGE> OF RAILROADS BEGINS: FOR NEARLY HALF A CENTURY, NO OTHER FORM OF TRANSPORTATION CHALLENGES RAIL
1869	ON MAY 10, AT PROMONTARY IN THE UTAH TERRITORY, <THE GOLDEN SPIKE> JOINS THE UNION PACIFIC AND CENTRAL PACIFIC RAILROADS, MARKING THE COMPLETION OF THE FIRST TRANSCONTINENTAL RAILROAD

1900	OTHER MODES OF TRANSPORTATION BEGIN TO CHALLENGE RAIL'S DOMINANCE OVER FREIGHT AND PASSENGER TRANSPORTATION
1916	THE NETWORK PEAKS AT 254,000 MILES OF RAIL
1945	WHILE ITS MARKET SHARE DECLINES, RAIL ENTERS THE POST-WAR ERA WITH A NEW SENSE OF OPTIMISM, WITH BILLIONS INVESTED DURING THE FOLLOWING YEARS IN NEW DIESEL LOCOMOTIVES, FREIGHT EQUIPMENT AND PASSENGER TRAINS
1960	THE LAST STEAM LOCOMOTIVE IN USE BY A MAJOR RAIL CORPORATION IS RETIRED
1975	THE LAST OF NINE MAJOR RAILROAD COMPANIES REPRESENTING ONE QUARTER OF U.S. TRACKAGE FILES FOR BANKRUPTCY
1980	THE STAGGERS RAIL ACT REDUCES THE INTERSTATE COMMERCE COMMISSION'S REGULATORY JURISDICTION OVER RAILROADS AND SPARKS COMPETITION, STIMULATING ADVANCES IN TECHNOLOGY AND THE CREATION OF HUNDREDS OF NEW SHORTLINE AND REGIONAL RAILROADS
2002	WITH MORE THAN 132,000 ROUTE MILES OF TRACK IN OPERATION, U.S. FREIGHT RAILROADS MOVE 1.38 TRILLION TON-MILES OF FREIGHT, MORE THAN EVER BEFORE

SOME TRAINS IN AMERICA
©CHRIS BOOT 2002
PHOTOGRAPHS ©ANDREW CROSS
WWW.ANDREWCROSS.CO.UK

FIRST EDITION 2002
©PRESTEL VERLAG,
MUNICH, LONDON, NEW YORK

MANDLSTRASSE 26
D-80802 MUNICH. GERMANY
TEL.:(89) 38-17-09-0
FAX:(89) 38-17-09-35
WWW.PRESTEL.DE

4 BLOOMSBURY PLACE
LONDON WC1A 2QA
TEL.: (020) 7323 5004
FAX: (020) 7636 8004

175 FIFTH AVENUE, SUITE 402
NEW YORK NY 10010
TEL.: (212) 995 2720
FAX: (212) 995 2733
WWW.PRESTEL.COM

LIBRARY OF CONGRESS CONTROL NUMBER: 2001096181

PRESTEL BOOKS ARE AVAILABLE WORLDWIDE. PLEASE CONTACT
YOUR NEAREST BOOKSELLER OR ANY OF THE ABOVE ADDRESSES
FOR INFORMATION CONCERNING YOUR LOCAL DISTRIBUTOR

DESIGNED BY VINCE FROST > FROST DESIGN LONDON
PRINTS BY PETER FRASER
PRODUCED BY CHRIS BOOT
PRINTED IN ITALY

ISBN: 3-7913-2679-1